OUT

LGBTQ Poland

Maciek Nabrdalik

THE NEW PRESS

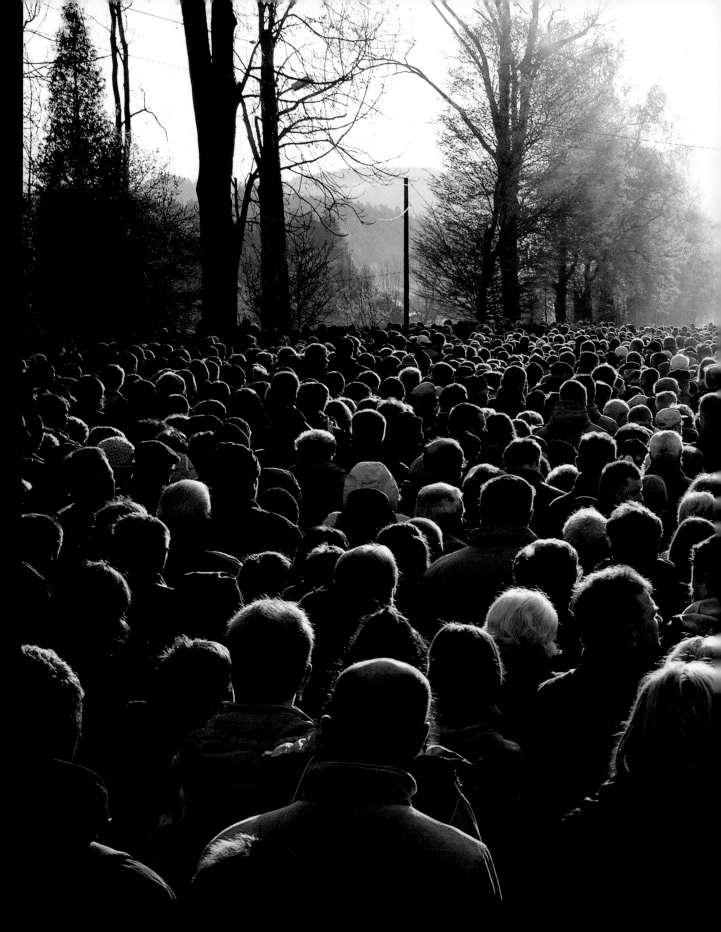

OUT

LGBTQ Poland

Maciek Nabrdalik

THE NEW PRESS

No part of this book may be reproduced, in any form, without written permission from the publisher.
Requests for permission to reproduce selections from this book should be mailed to: Permissions Department,
The New Press, 120 Wall Street, 31st floor, New York, NY 10005.

Published in the United States by The New Press, New York, 2018
Distributed by Two Rivers Distribution

ISBN 978-1-62097-369-1 (pbk)
ISBN 978-1-62097-370-7 (e-book)
CIP data is available

The New Press publishes books that promote and enrich public discussion and understanding of the issues vital to our
democracy and to a more equitable world. These books are made possible by the enthusiasm of our readers; the support
of a committed group of donors, large and small; the collaboration of our many partners in the independent media and
the not-for-profit sector; booksellers, who often hand-sell New Press books; librarians; and above all by our authors.

www.thenewpress.com

Book design and composition © 2018 by Emerson, Wajdowicz Studios (EWS)
This book was set in Helvetica Inserat, Helvetica Neue, Knockout HTF, FF Meta Pro, Myriad Pro and News Gothic BT.
Printed in the United States of America

10 9 8 7 6 5 4 3 2 1

Preface
JON STRYKER

This project was born out of conversations that I had with Jurek Wajdowicz. He is an accomplished art photographer and frequent collaborator of mine, and I am a lover of and collector of photography. I owe a great debt to Jurek and his design partner, Lisa LaRochelle, in bringing this book series to life.

Both Jurek and I have been extremely active in social justice causes—I as an activist and philanthropist and he as a creative collaborator with some of the household names in social change. Together, we set out with the ambitious goal to explore and illuminate the most intimate and personal dimensions of self, still too often treated as taboo: sexual orientation and gender identity and expression. These books continue to reveal the amazing multiplicity in these core aspects of our being, played out against a vast array of distinct and varied cultures and customs from around the world.

Photography is a powerful medium for communication that can transform our understanding and awareness of the world we live in. We believe the photographs in this series will forever alter our perceptions of the arbitrary boundaries that we draw between others and ourselves and, at the same time, will delight us with the broad spectrum of possibility for how we live our lives and love one another.

We are honored to have Maciek Nabrdalik as our collaborator in *OUT*. He and the other photographers in this ongoing series are more than craftsmen: they are communicators, translators, and facilitators of the kind of exchange that we hope will eventually allow all the world's people to live in greater harmony. ■

Jon Stryker, philanthropist, architect, and photography devotee, is the founder and board president of the Arcus Foundation, a global foundation promoting respect for diversity among peoples and in nature.

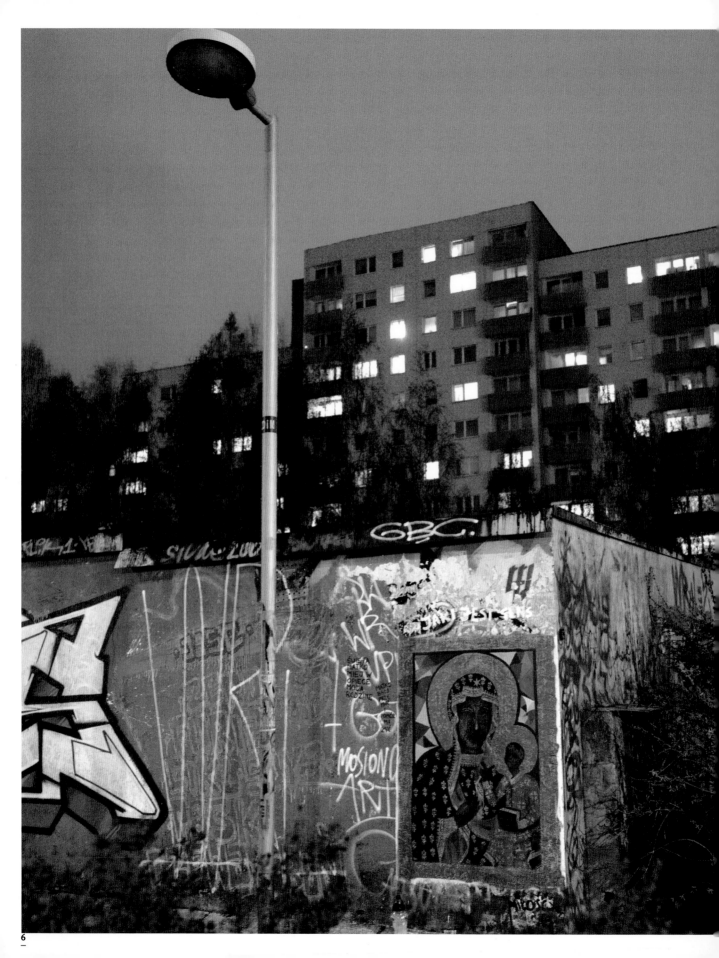

Foreword
MACIEK NABRDALIK

When I set out to photograph the LGBTQ community in Poland, I contacted quite a few organizations, community leaders, and friends in advance to learn more about where to go and what I might encounter. I traveled around Poland, documenting pride parades, workshops, transgender beauty contests, and clubs, and my first impression was very positive. But the longer I stayed and the farther I went from the major cities, I could see the rainbow begin to fade.

I grew up in Poland when it was almost uniformly a Catholic country. My hometown, Częstochowa, is a national shrine to the Virgin Mary.

From an early age, I have traveled widely outside of Poland, and I spent the last year in the United States. I returned to Poland for Christmas, and while I was there, I got to talking with a close uncle of mine. What started as a chat about Polish politics effortlessly segued into a discussion about religion, as the two are closely intertwined in Poland. From there, it was a short step to Pope Francis, who for many Poles is too progressive when it comes to the LGBTQ community. That was certainly the case for my uncle.

I wasn't sure if the things I heard from him that evening were new or if I only started hearing them after having been away for so long. Our conversation put a rift between us, and for the first time in my life, we didn't share Christmas dinner together. I felt I needed to stand up against the things he said. It wasn't just a theoretical issue anymore. I could think of many people—many close friends—who would have been hurt by his views. It made me realize that the story I took on is not about rainbow flags, or even about civil unions, same-sex marriage, or adoption. It is about something much more fundamental. It is about the right to live a normal life. It is about the right to be citizens of the complicated country that we all share.

This was when I decided on a different approach to presenting these images. These portraits were inspired by regular passport photographs, which usually stand as proof of identity and citizenship. Now, each portrait is shaded to indicate how comfortable that person was when we met with revealing their sexuality to the public.

Together with the interviews I did for the book, this is a portrait of Poland in all its complexity seen through their eyes. How these individuals feel and what they are afraid of is not only about them; it is about all of us. ■

Introduction: On Coming into the Light

ROBERT RIENT

In May 2015, fourteen-year-old Dominik Szymański hanged himself from a doorframe with his shoelaces. A middle-school freshman in Bieżuń, a small town of two thousand people near Warsaw, Dominik had been verbally and physically bullied by his peers. They had thrown stones at him, called him a "faggot" because of his appearance—he was well groomed and liked wearing skinny pants—and posted messages online urging him to kill himself. His teachers did nothing to help; some of them even humiliated him openly in front of his classmates.

Dominik's case is representative of the experiences of many members of the LGBTQ community throughout Poland. Homophobia and transphobia are overt and rampant in this country, although the official statistics do not, at first glance, support this. In 2014, Poland, which has a population of around 40 million, recorded only seven crimes against LGBTQ people. In 2015—the year that Dominik died—it did not record a single homophobic or transphobic crime. The reason for this oversight is that the Polish Criminal Code does not recognize hate crimes based on gender identity or sexual orientation, which makes it impossible to maintain accurate statistics. The omission also indirectly condones violence against the LGBTQ community. "Over half of the LGBTQ people who tried to report a crime were discouraged from doing so by the police," says Piotr Godzisz from Lambda Warsaw, Poland's oldest LGBTQ organization.

Of the European Union's 500 million citizens, only 75 million do not yet have legal access to civil unions and same-sex marriage. Half of them are Polish citizens. In 2015, the European chapter of the International Lesbian, Gay, Bisexual, Transgender, and Intersex Association analyzed the experiences and rights of LGBTQ people in Europe, considering fifty-two different categories, including the right to asylum, equal rights, hate-crime protections, marriage equality, the right to have a family, and the ability to change one's gender or name in public records. Poland ranked an abysmal thirty-three out of forty-nine.

The concentrated contempt for non-heterosexual cis people in Poland is the product of a medieval, patriarchal culture reinforced by the state and the powerful Catholic Church, to which the vast majority of Poles belong. It is a culture where chauvinism and misogyny, and therefore homophobia and transphobia, thrive. On being elected president in 2015, Andrzej Duda immediately declared that he was against marriage equality. When asked whether he would employ gay people in his office, he said, "I can't imagine half-naked people parading around the Chancellery." The president's father, Professor Jan Tadeusz Duda, publicly opined that it is the duty of the state to prevent homosexuality, which he described as a sad, acquired affliction. Meanwhile, the conservative Law and Justice Party, which won the majority in Parliament, has been actively promoting Krystyna Pawłowicz, a member of parliament who advocates that national healthcare should cover gay conversion therapy.

In this environment, a gay man can minimize the risk of verbal or physical abuse or discrimination in the workplace by staying in the closet and projecting an overtly masculine image. Likewise,

a woman can conceal her sexuality through presenting a conventional femininity, however anathema that may be to her. But there is no way for the transgender community to hide. They are regularly subjected to abuse and discrimination, especially transgender women. A transgender man meets with more approval because aspiring to be male seems logical in Poland's misogynistic society.

The Polish Criminal Code, formalized in 1932, was unusually liberal when it came to sexual relations among consenting adults. Male prostitution may have remained punishable by law until 1969, but same-sex sexual relations were legal. Nevertheless, the belief that being gay was an abnormality was pervasive, bolstered since 1945, when Poland became a Soviet state, by Stalinist notions about homosexuality as a pathology. For the LGBTQ community, the decades under communism were a period of suppression and surveillance.

This culminated on November 15, 1985, when the national police force entered private homes, schools, and workplaces and arrested people suspected of being gay. This marked the beginning of the two-year Operation Hyacinth, which led to the creation of a state archive of over 11,000 personal records, known as the "pink files," of known gay men and women and their acquaintances. The Polish Secret Service had already been keeping a registry of known gay and lesbian people since the late 1950s, but now it was forcing people to renounce being gay or carry a "Homosexual Card" if they were gay or lesbian, and threatening to reveal a person's sexual orientation to their family and co-workers. Some LGBTQ people left the country. Those who stayed lived in secrecy and fear.

Yet LGBTQ voices refused to be silenced. In a particularly well-known incident in 1985, *Polityka*, a popular weekly magazine, published a major article, "We Are Different," by Krzysztof Darski (the pseudonym of the openly gay activist Dariusz Prorok) describing the gay community as "ridiculed and marginalized, discriminated [against] by every single institution and social organization, tormented by homophobes, beaten and verbally abused by boors with a tacit approval of the esteemed of this world, alone and abandoned by the state, by the church, and by science." The article called for a homophile organization.

In 1990, shortly after the collapse of communism, the Lambda Association was legally registered in Poland—the first LGBTQ organization to do so. Gay magazines begin to appear, including the monthly *Inaczej* ("Differently"). Over the years, Lambda established local branches in a dozen cities. In 1992, actor Marek Barbasiewicz became the first celebrity to publicly come out, and in 1998, writer Izabela Morska became the first public figure to come out as lesbian. This was the first wave of emancipation.

Then came the groundbreaking "Let Them See Us" campaign in 2003. Organized by Kampania Przeciw Homofobii (Campaign Against Homophobia), which continues to be one of the largest and most recognizable LGBTQ rights organizations in Poland, the exhibit featured photographs of thirty gay and lesbian couples set against a winter landscape, casually dressed, holding hands, and looking straight into the camera. The photographs appeared on city billboards, in department stores, and in the media. Karolina Breguła, the photographer, aimed for an ordinary, everyday aesthetic so as to instill

a sense that any passerby might be LGBTQ. The billboards were regularly defaced and the authors of the endeavor attacked, but the photography campaign provoked a nationwide debate.

Around this time, Senator Maria Szyszkowa introduced the first draft of a bill supporting same-sex civil unions, which prompted an op-ed in the daily *Gazeta Wyborcza* by sociologist and LGBTQ activist Professor Jacek Kochanowski saying the LGBTQ community should have nothing less than same-sex marriage rights: "Gay people will not pretend to be married." The chair of the Polish Psychological Association, Zofia Milska-Wrzosińska, responded with an article titled "What gays are allowed to do"—a self-righteous, prejudiced, pseudoscientific treatise that expounds on traditional Polish homophobic thinking. But, although the bill on same-sex civil unions would eventually lapse, at that point nothing could undo the newfound visibility of the LGBTQ community.

In the early 2000s, photographer and journalist Szymon Niemiec and his colleagues attempted to organize the first pride parade in Warsaw, but they were refused permission by Mayor Lech Kaczyński. Nonetheless, an illegal march was held in 2005, even as Lambda Warszawa spokesperson Yga Kostrzewa and others associated with Fundacja Równości (the Equality Foundation) lodged a complaint with the European Court of Human Rights. The court declared the prohibition in breach of the European Convention on Human Rights. Still, in Poznań, a parade was stopped by a fascist countermarch chanting slogans such as "Gays to the gas chamber" and "We'll do to you what Hitler did to the Jews!" The police did not intervene, except to arrest sixty-five parade participants.

In 2008, transgender advocacy group Fundacja Trans-Fuzja was established, and in 2011 its co-founder Anna Grodzka became the first openly transgender member of parliament in Poland and in Europe, running for a liberal, anti-clerical political party, the Palikot Movement. She initiated the 2012 Gender Accordance Act, which passed in 2015 but was subsequently vetoed by President Duda. To date, sex reassignment surgery is not covered by national healthcare, and getting it is contingent upon a long, tedious, and humiliating process during which, among other things, the transgender person is required to sue their parents. The Gender Accordance Act would have overturned that.

Another key figure who was elected to Parliament as a candidate for the Palikot Movement is Robert Biedroń, the first openly gay member of parliament, a long-time LGBTQ activist, and the mayor of Słupsk since 2014. His influence has been immeasurable. In 2013, Nobel Peace Prize winner Lech Wałęsa, the first democratically elected president of Poland, said that LGBTQ people "have to know that they are a minority and adjust to smaller things, and not rise to the greatest heights. . . . A minority should not impose itself on the majority." Three years later, having worked with Biedroń, he admitted, "God created different people. That doesn't bother me. There has to be a place for every one of us."

Now, pride parades are held annually across Poland. We have our own social venues, festivals, movies, plays, and books, while dozens of

celebrities have come out as LGBTQ and straight allies have voiced their support for LGBTQ rights. Over thirty LGBTQ rights organizations now operate in Poland, including Miłość Nie Wyklucza (Love Doesn't Exclude), which fights for equal marriage rights for same-sex couples. Hubert Sobecki, its chair, claims that "a wave of emancipation is gathering momentum in Poland that will lead to equal rights for all." In March 2017, four same-sex couples who had been denied the right to form civil partnerships by the Polish courts appealed to the European Court of Human Rights. If it rules in the couples' favor, the court could compel the Polish government to legalize civil partnerships.

Meanwhile, the Polish Sexological Society has officially declared that sexual orientation "is not a matter of choice or a phase," a statement subsequently supported by the Polish Psychological Association. Professor Zbigniew Lew-Starowicz, a renowned Polish psychiatrist, publicly apologized to the gay community for having used electroconvulsive therapy to treat homosexuality. Elsewhere, the Campaign Against Homophobia in collaboration with the Christian LGBTQ group Wiara i Tęcza (Faith and Rainbow) and LGBTQ rights organization Tolerado organized the "Peace Be with You" movement. For the first time, straight Christians have expressed their public acceptance of LGBTQ people—a major breakthrough in a country where the Catholic Church has proved such a formidable opponent.

Yet, not all is cause for celebration. Since 2015, when the homophobic Law and Justice Party came into power, attacks against LGBTQ organizations and activists have intensified. Hate crimes and hate speech continue to go unreported, and young LGBTQ people are made to suffer verbal and physical abuse, or even take their own lives, as Dominik did. As Professor Krystyna Duniec notes, "After the initial intoxication with freedom, there typically comes a conservative backlash and totalitarian inclinations." Also, as the chair of Campaign Against Homophobia points out, while the visibility of LGBTQ people is fast becoming a fact, "in our patriarchal society, it is mostly just the visibility of gay men."

Mariusz Kurc, the editor-in-chief of Poland's only LGBTQ magazine, *Replika*, is optimistic: "Pope John Paul II once said, 'Don't be afraid.' Those words were read as an exhortation to abolish communism. Similarly, Robert Biedroń is encouraging LGBTQ people in multiple ways to set aside their fears and come out, and he is encouraging straight people not to be afraid to get to know the LGBTQ community." According to official polls, Biedroń, whose interview concludes this book, will be a candidate in the 2020 presidential elections.

Visibility is crucial in the process of self-becoming, of appearing as an equal person to one's relatives and colleagues and fellow citizens, of leaving fear behind in order to come fully into the light. The protagonists of this book are at the vanguard of emancipation—the inclusion of LGBTQ people as equal citizens. It is a vital step in reclaiming our right to safety, to freely inhabit the present, and—above all—to love. ∎

—Robert Rient, journalist and author of *Witness*

When I was a child, I knew I was a boy. I have an older brother, and most of my mother's friends have sons. I didn't grow up around girls. I have an intimate memory of walking into the bathroom and seeing my brother pee. I didn't sit on the toilet seat; instead, I tried to pee standing, just like him. It was the first moment I realized that something was wrong. I was five years old.

In kindergarten, I wouldn't use the girls' restroom. I'd come home if I needed to go. My parents kept asking me why. I also remember when we went to a wedding and my parents had me wear a dress. I tore it and said I wouldn't wear it. I never wore skirts or dresses. I hated it whenever anyone fixed my hair. My mom would comb it, braid it, or tie it in a ponytail, and I hated it. Before I received my first communion, I had to grow my hair long. I made my mom promise that as soon as the ceremony was over, I could cut it. All I could think about was having my hair cut, and as soon as the celebrations were over, I told my mom, "Let's go to have my hair cut." "But today is Sunday," she said. "Mom, you promised!" On Monday, I was up at 6 a.m., waiting for the hair salon two blocks away to open. I went all by myself. To an outsider it might have seemed like little had changed, but to me it made a world of difference.

I fully understood what was going on with me when my breasts started to grow and I had to start wearing a bra. "Jesus," I thought after I put on my first bra, and I knew it was a done deal. Until then, I had believed that maybe something would change. That was my hope. But nothing changed. Nothing could change. And then came my period. Every moment of growing up felt like a nail in my coffin. I was being nailed up. Bang, bang, bang.

It's hard to believe that nobody noticed anything. I went to my P.E. classes with the other boys. The teacher who taught the girls in my class told me at the beginning of the class, "Fine, Edyta, go join the boys." I approached the teacher who taught the boys and asked him if I could play soccer with them. I've always done everything that men do. I »

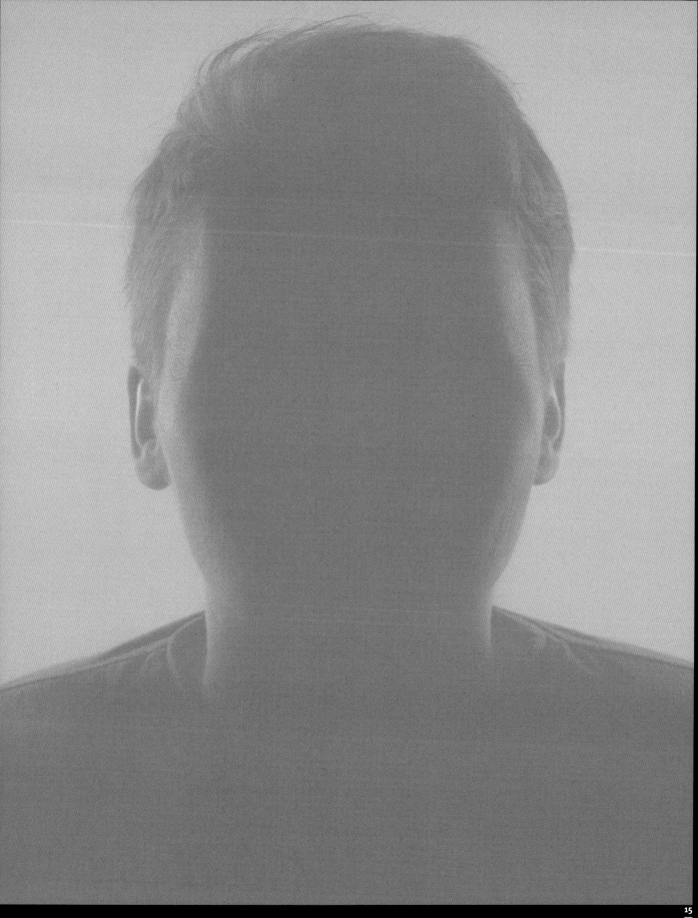

only had one doll that I would call "Krzysiek." My male friends treated me like a buddy who knows about women. They would ask, "What should I do if my girlfriend gets angry?" And I would explain, "You have to be patient, it'll pass." I explained to them what a period was. They knew they could ask me anything.

My dad always said that he wanted a daughter first, then a son. He treated my older brother like a girl and me like a boy. He taught me boxing: "Remember, if anyone picks on you, smash their face." When I was given demerits on the first day of school, my mom sent me to talk to my dad. "What did he do?" he asked. "He pulled my hair." "Did you hit him?" "Yes." "Good." I would fight in any argument with other boys. I often walked around with a black eye. Can you imagine your daughter coming home with a black eye, all happy? I know how to fix electric sockets and install ceramic tiles. My brother is helpless when it comes to these things—clueless. Sometimes I take care of him and run errands—never the other way round.

I can't be completely open with my brother, because he is like my mom. I tried to talk to him once, but he just laughed at me. It was when I decided to get a degree in resocialization pedagogy. During the oral exam they asked if homosexuality was a sickness. Everyone before me said it was, but I said it wasn't. They asked why I thought that. It was easy to explain. At home, I talked about this with my brother, and he said, "What are you talking about?" He had a different mind-set. I had thought hard about being gay, put it side by side with my own experiences, and it was clear to me that being gay can't be "cured" with medication or therapy. But I knew, too, that I couldn't simply put on a skirt and be fine.

If I had been born in a different time, I might have found support. Nowadays, the younger generation can get all their information from the Internet. But my generation? Where were we supposed to go? To a school psychologist, who either pretended not to understand or sent you to a psychiatrist? That was it. I had no one to ask, no one to talk to. I talked to a school psychologist in grade

school. I asked her if she could see who I was, but she completely ignored me—like most people I encountered. It's not that I was withdrawn or didn't want to talk about myself. There was no one anywhere on the receiving end. I felt completely alienated, even from my parents. I communicated it in different ways to them, and I don't believe that they never saw it. They still pretend they don't, and I'm forty now. I've often heard them describe me as a tomboy, but they never asked me why I am the way I am. And I won't bring it up either, because they are both about seventy years old now. I don't think they would survive this conversation. I always say I have a grudge against them. I do. I can't imagine having a child, noticing this about her, and not asking her about it. Not a word.

I don't wear makeup. I have never bought lipstick. I wore makeup once when I took part in a TV game show. I won, but I was afraid to watch it later. I was afraid to see my face in makeup. I've never had my nails done. I don't shop for women's clothes, because I don't like them. I did try to buy a dress once, but I didn't even try it on. I couldn't look in the mirror.

If you're gay, you don't have to change yourself and your image. But if you're trans, you have to change physically, and the process of being accepted is different. Besides, you'll never be seen as fully human.

I've been in a relationship for the past ten years. About three years ago, I asked my partner, "Would you be happier either way?" My partner said, "If you accept yourself the way you are, let's leave it and see what life brings."

Maybe our conversation will be a chance for those who read it to do something for themselves. Today, there are organizations, programs, the very notion of coming out. Back in the day, if you were different, you were alone. I didn't even seek out a community. I lived quietly with it all. I had to process it all by myself. I've had to put this puzzle together in my own way, and I want it to stay the way I put it together. But I would like my name to be Miłosz.

I have two early memories that are important for me. The first is as a four-year-old boy, being at my grandpa's forge—he was a blacksmith. The second comes two years later. I remember trying on one of my mother's dresses. I used to dress up at home. I must have been allowed to do that. I think my family had an idea of what was going on, but they didn't mind what I was doing because it wasn't too conspicuous.

Those two worlds—male and female—have overlapped all my life. I work as a car mechanic, although I'm a farming technician by training, specializing in the cultivation of grain and crop plants. In the eighties, people would repair a lot of machines on their own. I helped my grandpa, and this is how I learned mechanics. When a tractor broke down, I was called to help.

I graduated high school. My plans to study sociology and philosophy failed. I worked in a men's clothing store for ten years. This is when I got married. My wife persuaded me to go into finishing work, but it wasn't my cup of tea. I had an argument with my employer, quit my job, and became a construction worker. My marriage fell apart. Our breakup was a catastrophe. I regret it because of my seven-year-old daughter. I have no contact with her. She lives 200 kilometers away from me. I try to call her, but my wife makes it difficult. If she were different, I would probably come back, but I know that she's not going to stop reproaching me for leaving.

I packed my things in my Volvo 245 and went to Warsaw. I said, "We'll see what happens." I lived out of my car for three weeks. I found work at a gas station. This was the easy part. The hard part was that 60 percent of my salary went to pay alimony. I was left with 80 zloty. I always tried to pay alimony to the extent I could. During those hard years, I didn't have the money to buy dresses. I've been slowly turning the corner. For three years I've been making knives. It's a very male activity. I can't imagine forging knives in a dress. »

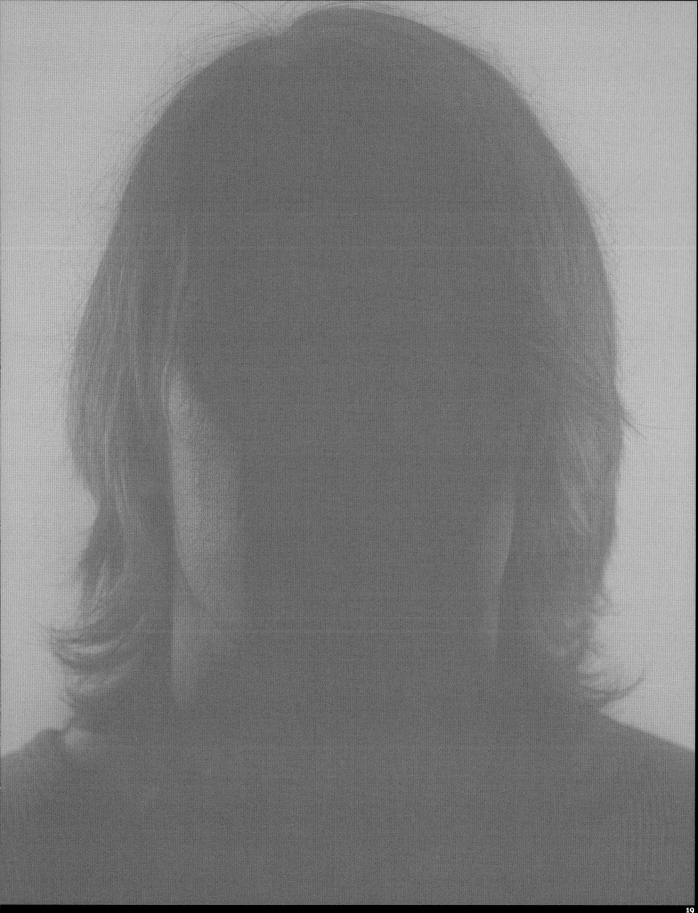

While I was still married to my wife, I would wear leggings under my trousers. She might have suspected something, but I never told her. She's very conservative.

I'm now with Monika. I met her online. I'd met a few women this way, but we had different needs. I was looking for someone to be with. After dating for three months, I asked Monika if I could move in with her. She agreed. I didn't immediately jump out of the closet dressed up. It was a gradual process. I could see that she wanted a relationship with a man. I had to find a happy medium. I was relieved when I opened up to her. Half of our closet is mine, and Monika dresses me.

I wonder what other cross-dressers are like. It seems to me that they are more effeminate. I don't know any. I don't know what their relationships are like, whether they hide at all from their partners. I feel like I can talk to anyone about this, but I don't feel the need to.

It's weird. Would you take your car to the repair shop where the mechanic greets you wearing a skirt? Most people wouldn't understand this, though it really shouldn't bother anyone. How is that different than wearing, say, a diving suit? In Poland, if you're a cross-dresser, you're called a pervert. It's sad. I wonder what would have been possible for me in a different country. Would I be going out wearing silicone breasts?

I look grotesque in makeup. I am too masculine, but I do put makeup on when I'm at home. I feel like I look good in women's clothes. Dressing up doesn't change my character. I don't become a woman, and I don't want to become one. For me, gender reassignment is no guarantee you will be who you want to be. What I do is not a compulsion, but an enjoyable addition to life, like putting sugar in your tea. I don't dress up only for myself, but I can't go out dressed up because people wouldn't understand. It's not something I'd like to fight or die for. It's something I simply enjoy.

Poles are said to be homophobic, but they elected Anka Grodzka—a transgender symbol—into Parliament in 2011. Individually, people understand that everyone has their own needs. As a group, people think differently. They crank up the fear of the other. Any attempt to explain that I am a separate being, that I have my own life, that I have rights usually leads people to act defensively and aggressively. I try to explain that they have nothing to fear. If I don't feel any desire toward you, you have nothing to fear from me, and you're not going to become any less straight if you spend time with a gay man. You're not going to stop being attracted to women if you spend time with me. "Transgenderism" is not a plague. People are afraid of what their everyday vocabulary cannot contain.

It's nothing new to say that being trans is a form of desire. I've felt this desire since before I could even name it. I remember wanting things to be different. Later, this desire became a conscious desire. My internal image of myself did not match my external image of myself.

In the nineties, I hardly spoke to anyone about gay, lesbian, and trans people. All those developments were happening outside of Poland.

Here, everything was happening internally, within the boundaries of my own body. I grew up in an era when all you could do was consult an encyclopedia or women's magazines. I couldn't find any explanation in the encyclopedia, but the magazines would sometime mention transsexualism. I would cut out these articles and save them in a special folder. Here was a flicker of awareness. Someone had given it a name. I needed that name. I could fit myself to what it described.

I was fortunate in my relations with people—my friends, family, aunts, grandmas, and cousins. I waited a long time before I told them that I was transsexual, but I couldn't hide it. It slipped through in gestures, words, and actions. It poured out of me and it dominated my whole life. When I spoke with transgender people and gay people, we would use a whole palette of words to describe what we felt, but the moments when we would understand each other were fleeting. How can you explain to someone that every minute of your life inside you there's this desire to change?

People pass me in the staircase, in the street. They remember a girl playing in the street, entering the building, and now, they see »

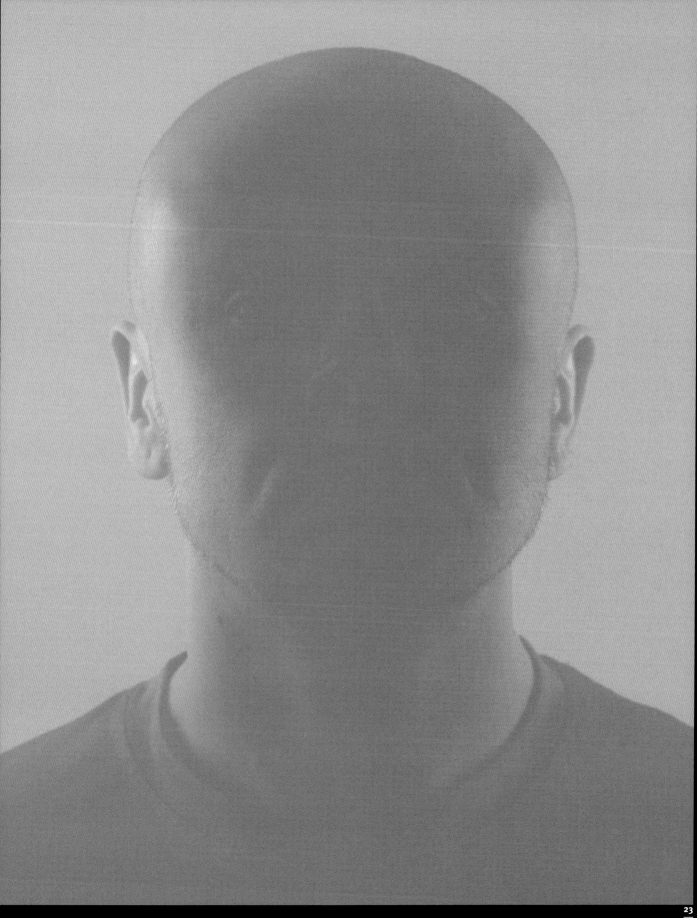

somebody else. They remember that there were three daughters in the family, not two daughters and a son. Back then, it was the parents who decided the gender of their child. I resented them for not asking who I wanted to be—a boy or a girl. They didn't know that as a teenager I acted out because my body was pinching me. I could not approach a female classmate and say, "I like you. I want you." I couldn't openly court her, because I was her friend and it would disgust people if I did. My parents noticed that I was different—they were more permissive than most, but they were more concerned about the safety of my sisters than mine.

My parents never regretted having me. At first, my mom didn't know how to help me. She saw how much I wanted to change, and she must have wondered what to do. I said that I had already made up my mind and I wouldn't allow any emotional blackmail. At twenty-five, I decided to come out. I was on my own, without the support of family and friends. I isolated myself. I was afraid. I traveled all over Poland to talk to doctors. I talked with a psychologist, a sexologist, an endocrinologist, and also with my colleagues. I had to go to court. I had to change my papers. In hindsight, it seems unreal that I went through all this and that I could have ever hated myself. Society, always in the shadow of the cross, forced me into a certain role. At home, I was never

made to feel that it was a sin, but I did feel guilty because back then I believed that this wasn't what God wanted. According to our law, I had to sue my parents, and so I took them to court. My dad answered all the questions, and when the judge asked him, "Do you have a son?" he looked into my eyes and said, "Yes, of course, I have a son."

The process of accepting myself never ends. At some point the external transformation ends and the internal work continues—an enormous task. I was seeking congruence. I discovered that I also needed peace and balance to interact with others.

My parents embarked on a similar lengthy process of coming to terms with this. I didn't want just to be tolerated; I wanted to be accepted, I wanted them to understand, I wanted us to find a common language. You can't make up for years of not talking about yourself in just one conversation with your sister or mother. They are still asking questions, which I patiently answer. The TV helps. My dad sometimes calls me: "There's a show on about people like you." I wasn't comfortable with the term "people like you," but it was also an opportunity to get closer, to explain. We eventually came to talk about penises and vaginas and breasts. There are no longer any taboo subjects in my family. My mom talked with the neighbors, uncles, and aunts about it. I have one living grandma, and she's the only one I decided not to tell, but my mom took it upon herself to tell

her. One day, when I was casually talking to my sister about myself in a supermarket, it dawned on me that my family had also made a major decision in their lives. It was also an important period for them.

During transition everything becomes more colorful, more powerful; everything picks up pace. I felt as if I had left a prison, but still retained the habits of a prisoner. I was afraid I would be persecuted. I suppressed my professional potential. During my transition, after I had received my documents, I was unemployed for two years. I became depressed. I didn't know how to inhabit my new role as a twenty-seven-year-old man who had been out of work for two years. I had to undergo a process of resocialization. During therapy, I discovered a source of guilt that I hadn't been able to name for a long time: I had made my parents' life chaotic. I had forced them to change, even though they'd had their own expectations of me as their daughter. They never badgered me to find a boyfriend or a husband. They wanted to know how they could help me.

The reaction of my closest family members and friends was a pleasant surprise. I had been prepared for hysteria, for rejection and a lack of understanding. I spoke with my best friend, and he said he had always known, but that he was waiting for me to start the conversation and tell him my new name. He grasped it right away.

Another friend learned about it two days before leaving for Greece. She confessed that all through our friendship she had been uneasy about who she had been spending time with, about who I really was. I looked masculine. I could also do house renovations or fix a car. In those days, this wasn't something you expected of women.

Now, I'm a regular guy. It takes me three days to grow facial hair. I work in a warehouse among men. There, I am not conspicuously trans. I remember when I started this job. I entered a new environment as Jakub. I had been taking hormones for four years. I was paranoid that someone would see through me, that I would reveal myself at the wrong moment. In the changing room, I felt like everyone could see that I was different. I was afraid of being attacked. When I was younger, I was often verbally attacked, demeaned. I got used to it, but those words stayed in my head after I transitioned. Now, it doesn't bother me anymore. I stopped feeling like I looked or acted differently, that I had conspicuously feminine features that would give me away and make me feel vulnerable.

For some, normality means a family or a child. For others it means official documents. For still others it means muscles, physicality. For me, it means looking into a mirror without avoiding my own eyes. I feel like I have at last met someone I've been waiting for for a very long time.

Stanisław Orszulak

The grass is always greener on the other side. I've always wanted to leave Poland and live abroad, especially in an English-speaking country, because those places offer more opportunities and are more open. That said, my situation in Poland is better than other people's. I come from an upper-middle-class family. I go to a private high school, just like my brothers. We're better off than many other people in Poland. If I were in a public school and came out as trans, I don't know what the reaction would be. But because I'm at a school famous for its openness, a school that holds feminist views and that is multicultural, I was accepted right away.

When I was a freshman in high school, people saw me as a girl, but I didn't admit I was transgender, because I wasn't sure. It was obvious that I was part masculine, part feminine. I used both female and male gender pronouns. I would introduce myself as Misza. A few people wanted to know what was going on. I spoke to my teacher and later to the headmistress. She invited me to the teachers' meeting. I said that I identify as male and asked that they call me Stanisław. They accepted it without surprise. They only asked if I wanted them to change my name in the online class register. It was great. Even the old-fashioned teacher called me "Stanisław" when she was checking the attendance a day after I came out. For me, it was a sign of acceptance. My classmates found out during homeroom. A moment later, everyone at school knew. Nobody came up to me asking, "What's going on?"

When I asked the headmistress which restroom I should use, she was surprised that there were no co-ed restrooms in the school. She thought that we had to immediately change that, and I should spearhead the idea. Maybe we'll get them next year. At the moment, I am using the men's restrooms, and it's a bit strange. There are no trash cans in the stalls, there's pee on the toilet seats and on the floor, and it stinks. How do you miss the toilet when you pee? And what are urinals about? Yet another level of social integration that I'm not dealing with well. I enter the stall, I have to wipe everything, and then I sit down. It's awful.

One day I went to the cinema with my girlfriends. We entered the main restroom together, and I was standing by the basin waiting for them when a woman came out of a stall, looked me up and down, and said, "It's a women's restroom." It made me feel good. I went to the men's restroom right away. I don't like going into women's restrooms. I only choose it if I know that I won't be safe in the men's restroom. At least in men's »

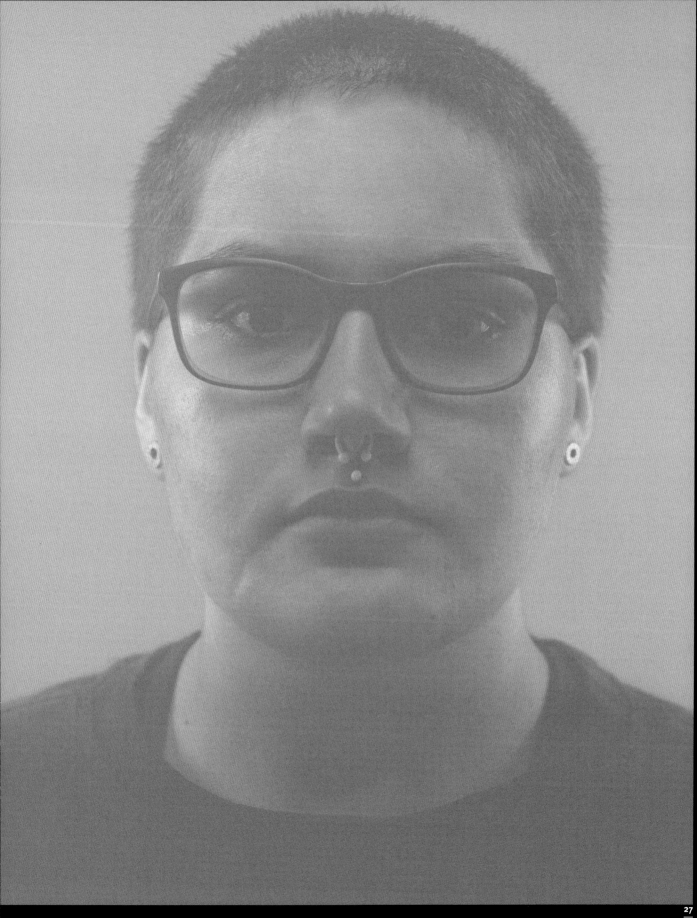

restrooms I don't have to look at anyone. In women's restrooms, people sometimes look at me. Right now at school I function as a boy. This is how people treat me. I've been lucky to meet people who are not *trying* to see a boy in me. They simply see me as a boy. I've been thinking about things that I haven't thought about before, that I haven't noticed. For example, when I take part in a discussion as a boy, my voice is heard much more than the girls'. I have to deal with the whole range of privilege that men have in a patriarchy.

All my life I've encountered people who assumed that you were straight until you proved to them that you weren't. I've had to fight to live my own way. In middle school, I came out as bisexual. I was using the women's dressing room at shops, and I decided to tell my girlfriends about it. When one of their mothers found out, she told my mom. She thought it was wrong to let everyone know that I was bi.

My parents are not divorced. These days, everyone is divorced, so I'm a bit surprised that they're still together. Mom says she has no complaints against Dad. If we have a relationship, it's a strained one. I came out to my mom in a very stupid way. We were sitting in a car and I asked, "Mom, what do you think about the name Stanisław?" "Why? Do you want to change sex?" "Yes." She sounded as if she wanted to hear that it wasn't true. She might have suspected something. A year earlier, I

had shed my mask and stopped wearing dresses. She said I was only doing this to attract attention, that it wasn't anything serious, that when she was my age, she looked like a tomboy, too. The last thing she said about this to me was: "I told your brothers that they could be gay and I would accept them." She doesn't accept me. She doesn't see me as transgender, and she'd sooner accept me if I were a lesbian. She also said that if I had indicated earlier that I wasn't a girl, she might have been able to accept it now. But there never was a moment to question my femininity. She still thinks that I am a woman. I was a great actor. I deserve an Oscar.

I have four brothers. I would play with Legos with my two older brothers, and I also had my Barbie dolls and a big house for them that my parents had built. In kindergarten, I played with everyone. Then, at school, groups formed, and I noticed that I was different than the boys and the girls. I felt I didn't fit in the group I was in. I refused to collect stickers and play Tamagotchi with my girlfriends. I wasn't like them, and I liked that I wasn't like them. Later, I made friends with a really girly girl, and I realized that I thought and felt differently. When I was nine, I asked my mom to test my testosterone levels. I'd read about it in an encyclopedia. She told me to leave it alone. Later, I got my first period. I tried to pretend to be a girl. I tried to be feminine. I helped my parents become

familiar with my girliness. I even wore high heels. But all the time I would wonder how girls get up in the morning, put on makeup, put on dresses, and not get tired. For me, it was like putting on a costume. I would read women's magazines and memorize what I'd read, as if I were studying what it means to be a woman. I had to learn it.

Then, the "boyfriend" style became popular. I couldn't wear those clothes, because I was too large. They didn't have clothes in my size. So, I decided to wear the men's version. I put on a man's sweatshirt and saw myself in the mirror. It was as if the curtain had gone up. There was no way back. I looked like a boy. I went online and found information on men undergoing transition, definitions, non-binary genders. Later, once I'd been through a hyper-masculine phase, I started to relax. I noticed that when I looked inside myself, I could see no gender. I present as masculine because it comes more naturally to me. When someone addresses me as "sir" in the street, I feel better than if I hear "ma'am." I'd like to transition. I feel I am a male asexual.

When I was a little girl and imagined my future, I couldn't see myself in that future; I could only see my surroundings. Now that I know I don't want to be a woman, when I think about the future, I can see who I want to be and what I want to do. I see myself free. I see myself with a beard. I see myself with a flat chest. I want to have a mastectomy, and

in a few years, I'm going to have facial hair that I'll be proud of. I'll wear red lipstick with the beard. They'll look great together.

Right now, I'm not fully myself. My body doesn't let me move on, evolve. Now, when it's very hot, I'd like to wear a dress because dresses are great for hot weather, but I can't, because if I went to school dressed like that, people would ask me what I was doing. They'd look at my breasts, my hips. I wouldn't look like a man wearing a dress, I'd look like a woman. But when I start taking testosterone, when I have that mastectomy, and my body stops being an obstacle, I can wear red lipstick, and I'm going to look like a man wearing lipstick and not like a girl.

I wear a chest binder. I prefer fall and winter when I can wear baggy clothes. Right now, I'm suffocating in that binder. If I take it off, my mother is going to refer to me as a girl, just like my father and most of my siblings do. My older brother accepts me as a boy. He refers to me as "he" even when my breasts are noticeable. Unless he's angry with me, then he calls me "she." My two younger brothers refer to me as "he" in about 12 percent of situations. Still, it's better than nothing.

I recently bought myself some bracelets—strings with a pendant. Mom grabbed my hand and asked, "What does it mean? Are you a woman »

again?" I said, "What???" No, it doesn't mean anything. It means that I like wearing bracelets. She knows that I have a flower crown and high heels in my room. We haven't talked much about my gender ever since she strongly expressed her disapproval of me. I'm waiting for my testosterone prescription. After that, she won't be able to say anything anymore. I've been referred to a sex clinic, and I'm in the system. I'm in therapy. I've seen a sexologist. Slowly, they're trying to determine that I am trans. I have referrals for various tests.

I ran into a friend from school. She asked, "How have you been?" "Well, you know, old stuff, new gender." "What do you mean?" I explained that I want to transition from female to male. She looked at me. She looked down at my crotch, then she looked at me again. She assumed that my genitals would change, which shows how being transgender is often confused with being transsexual. I don't need surgery. It's expensive, invasive, and the side effects are not great.

There is a training center at the sex clinic. They asked me if I wanted to talk to the students there. I agreed. Someone asked me what my sexual orientation was. I said I was bi. I simplified it because I didn't want to give them a headache. I said that I used to have a boyfriend, but we didn't have sex. The students got wrapped up in my story: "So, you're more like a straight female.

But how can you have preferences if you haven't had sex? How can you know who you prefer without having sex with them?" If I like someone, then I like someone. I don't relate to people through their gender. If we're compatible, then this compatibility will help us solve the problem of sex. But why sex? I'm more about romantic connections, about mutual connection—we're together. It may turn out that the other person doesn't want sex at all. It's about the relationship rather than sex.

Once, I told my mom that I was depressed and would like to see a therapist. She said I was just making it all up. A teacher I confided in talked to my mother. Only then did we go to see a therapist. But Mom still doesn't believe it. Five years ago, I spent a month in a psychiatric hospital. Three specialists diagnosed me with depression, but Mom still thought I was trying to attract attention to myself. I was diagnosed with a personality disorder. I'll always have a predisposition for depression. It's complicated. I'm working on it. I started cutting myself five years ago. There was one recent episode—these scars on my arms. It's ugly. I'm not proud of my scars, but I shouldn't be ashamed of them either. It has nothing to do with being macho. I didn't fight with a tiger. These six lines are an expression of sadness. I hope that when I find myself in a bad place next time, I will be smarter.

I always save my secret for later. It goes more or less like this: "Listen, there's something you need to know about me, but not now." It's especially the case when I care about someone. It doesn't matter if that person is male or female. I always delay the moment of truth. When I start speaking, everyone thinks the worst—that I'm ill, that something terrible has happened. When I finally tell them my secret, they usually say, "We know. You'd have to be an idiot not to figure it out."

For me, it hasn't always been this clear. Being among girls, having girlfriends, building dollhouses never felt quite right to me. I played with boys. I liked cars and kicking a ball. When you're seven, you're not aware that you'd like to be a different gender, but I happened to say once in grade school, in front of a group of kids, "You'll see, one day I'm going to be a boy." From then on, everyone started pointing their finger at me. Friendships ended. A light went out. My mom would keep trying to squeeze me into clothes that I hated. Wearing a skirt would not stop me from playing soccer. What was worse was tying my hair into a ponytail, making a girl out of me. Toy handcuffs and a gun were the best gift. When I

was given a doll, it would inevitably end up with a severed head. It should have made my parents think, but it didn't.

"It" kept coming back—every time with double the force. One day I woke up and said, "I can't live like this anymore." My partner helped me. She started looking for information online, and it turned out that there was a way I could live with myself, that I could fully show myself. Now, for the last three years, I haven't had to divide myself into two people. My community knows. I've started using male gender pronouns. I'm learning "male activities." My male friends help me with that.

Sometimes people are born in the wrong body. What's in your head doesn't match what's on the outside. I don't divide people into normal and trans. Being trans is not a different category of being human. That way of thinking is a mistake, and it's a source of great suffering for trans people. I think people who hide from others, who play a role and start a family, are destined to be unhappy. I've never called myself a lesbian. I am a man, so my relationships with women are not lesbian. I've been in relationships with men. They »

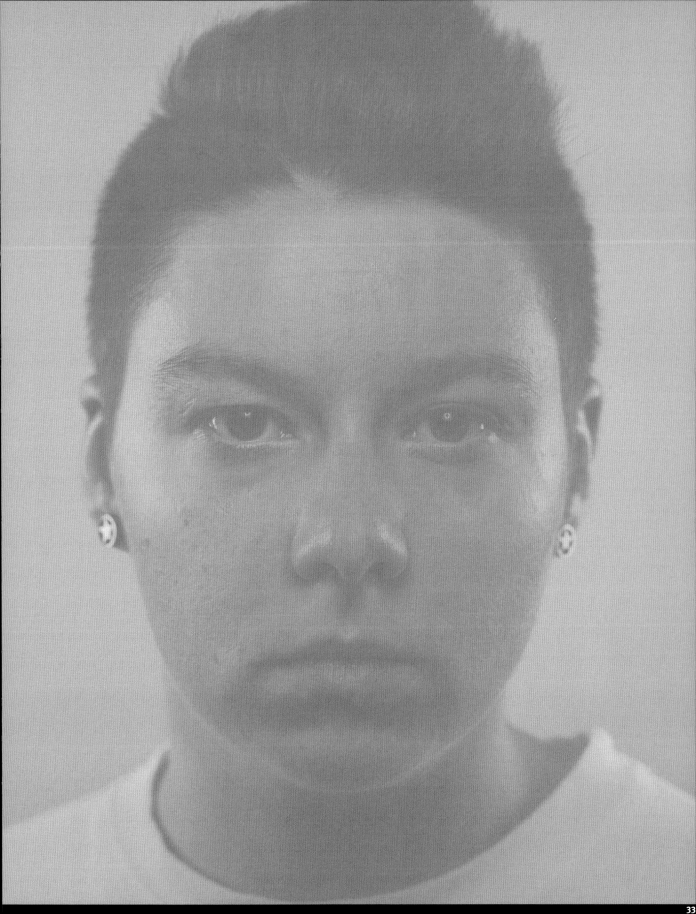

didn't work out. I am stronger, domineering. What man would put up with being bossed around, with falling into line? Some people like it, which I find strange. I don't get hysterical like women do. I don't allow myself to be sentimental. But until my hormones are regulated, what's in my head continues to struggle against what my body tells me. I think that a man who pities himself or who's dying just because he's having a headache is not a true man. A man should be strong, firm, well organized. If he has a family, he should be responsible for it and should act in a way that gives his wife and children a sense of security.

My parents separated and my mom took me and moved in with her parents—from the south of Poland to the north. My father could have kept in touch with me, but he chose not to. He has restricted parental rights. I can't say that I don't have anything to do with him. He pays alimony, so I have a financial relationship with him. I saw him two years ago. How can I be myself when I'm with him? How can I tell him everything, if I don't trust him? He wasn't there for me at the most important moments of my life. I don't know him, and I can't predict how he might react. I don't care

what he thinks. For me, he doesn't exist, but he'll find out about me eventually. Polish law requires that I sue my parents. It's an old and out-of-date law, but the current president is against changing it. Meanwhile, it takes six months for the court ruling to become final. Imagine me with a beard and a muscular physique and having to deal with some official matter at a government office. I'll show my ID and the clerk will think that it's some kind of misunderstanding. It's humiliating. A friend of mine is in a similar situation. He can't collect certified mail at the post office as himself. Instead, he writes himself an authorization and pretends to be his own relative.

My mom is very tolerant. This is how she raised me: you can't laugh at other people and insult them because of illness, skin color, or religion.

She was the one who initiated the conversation, but she didn't believe me right away. I thought that once I finally said it, I'd shed this burden and it would get easier. It didn't. My mom got upset. She said it was a stupid decision made in the heat of the moment, that I hadn't thought it through, that it was because there hadn't been a real father figure in our house—that kind of nonsense. She

promised that if I brought a doctor's diagnosis, she'd accept it. I did. It said black on white that it wasn't temporary, but she still doesn't want to accept it. I live with her because I don't feel I can afford expensive treatment.

I've been through all the exams. I've been prescribed hormones, but I haven't been able to take them because Mom gets hysterical the moment she hears about it. She reverts to emotional blackmail. She says, "If you tell your grandparents, it will kill them." I tell her, "They're not going to get a heart attack when they hear it." She says, "But with their high blood pressure they could have a stroke." From a medical point of view, I know that this news cannot kill them, even if they both have high blood pressure.

My grandparents live far out in the country. Only one bus goes there, and most of the people are over forty. These things are unacceptable there. People don't listen. Getting a drink is the most important thing for them. They don't aspire to anything else. Their thinking is in line with the governing party: "A boy is a boy. A girl is a girl. Husband and wife." During the summer, I'm going to work at a dry cleaner's there, so I've postponed hormone

therapy until September. I know it isn't fair on my grandparents not to tell them about my therapy in advance, but next time I visit them, in six months' time, I'll be greeting them with a male voice.

I'm not going to change suddenly, but people at work would immediately see that something was going on. They wouldn't understand. They've already been picking up on things: "You walk like a man," "What's that you're wearing?" I don't want to put my grandparents at risk of ridicule. I feel close to them. They raised me. But I don't know how to tell them.

In grad school, everyone accepted my decision. Two younger faculty members were very happy: "That's great, congratulations! Grad school is the best time to transition. How can we help you?" Other professors perhaps weren't as enthusiastic, but they understood. I thought they would be shocked. They still call me Patrycja, though, and I don't have the courage to ask them to call me Maks. They are my intellectual gurus, former military men who have their principles. I don't want to get on their bad side. Maybe they'll start addressing me differently when I start to change, when I start to sound and look different.

Jarek Chlipała

I've been performing for three years under the stage name Baby Jane. Being a drag queen is an expensive hobby. I've invested a lot of money in Baby; perhaps when Baby becomes a famous brand, I'll get a return on my investment. I had a friend who did drag as well. He was the face of the most famous drag club in Kraków; he was the resident queen there. He would greet and entertain the guests and introduce star performances. My dream was to dress as Marie Antoinette, my favorite character. He suggested that I take part in the drag queen festival in Poznań. When my mom heard about this, she laughed for fifteen minutes straight. She couldn't imagine me in a female costume. Fun turned into something more. I became the first runner-up at Drag Queen Wielkopolska. When my mom learned that I'd won a prize and saw my performance, she said "You should pursue this." In Poland, it's assumed that drag is a caricature of femininity. That's not me. I'd rather shave my legs than wear six pairs of tights.

I like to provoke extreme emotions. I don't perform as often as my fellow queens do, because I like to be well prepared, I like to show something more. They just hop around the stage, from one end to another, while I like to address politics, add some substance. The result is something that can provoke, or offend, or incite emotions. When the government abolished the Anti-Discrimination Commission, I had to take a stance. During my performance, I brandished photos of the late presidential couple and the plane.[1] Not everybody liked it. Some people compared it to pissing on a votive candle.

My drag has nothing to do with a fetish for women's clothes. I'm twenty-seven, bisexual, and have been in a relationship with a younger man, Norbert, for eleven years. He was my former girlfriend's friend. I realized that I had confused two kinds of love and loved her more like a sister than a girlfriend. I've always claimed that it's not important if I'm with a woman or with a man. What matters more is that I can love and be loved.

My mom knows that I am gay. She considers Norbert her second son. She visits us and stays for a week. My dad is a typical electrician at a Kraków foundry. He has tunnel vision. He calls all politicians and priests "faggots." He doesn't ≫

[1] On April 10, 2010, a Polish Air Force plane crashed near the city of Smolensk, Russia, killing all ninety-six people on board. Among the victims were the president of Poland, Lech Kaczyński, and his wife, Maria. The accident has prompted a number of conspiracy theories circulated by the Law and Justice Party.

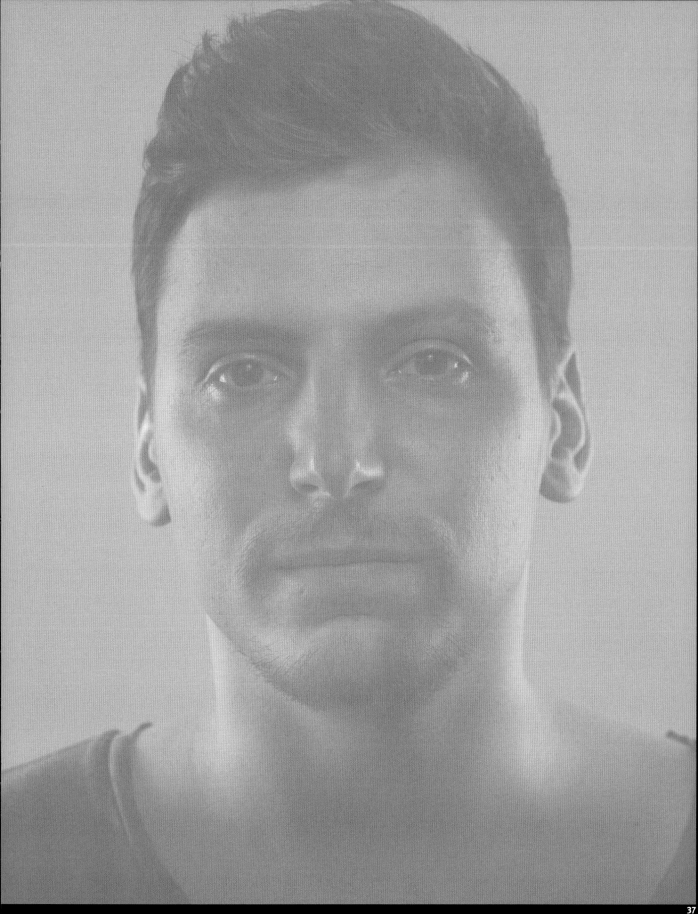

see any difference between a gay man and a pedophile.[2] When I recently went to a pride parade, he thought he saw me on TV. He called Mom: "I saw Jarek, he was marching with those faggots, wearing a yellow dress!" He knew everything but didn't want to talk to me about it.

Norbert spends every Christmas with us. It's just us and my parents. I don't have siblings. Christmas is important in my family—my mom cooks, and, unlike some families, we don't disperse immediately after dinner. Norbert and I behave like a couple. We cuddle, and either I sit on his lap or he sits on mine.

At first, my dad would say, "I'll kick that faggot's butt so hard he'll get an orgasm. When will Jarek finally come to his senses? I want to have grandkids." His army buddy has a daughter. We grew up together. Dad thought I'd marry her. He was angry when she got pregnant by someone else. I can see how he acts when he sees small children. He runs to the store to buy lollipops or ice cream. I'm sure if I had children, they would have a good life. He would spoil them. His Christmas wish is always the same: "You know what I want."

Dad resented me for not going to college. He graduated from a professional technical school at the age of fifty, and I am proud of him. He used to be at the top in the World Judo Championships. Now, after all the sitting at the computer and drinking beer, he looks different.

I know my dad loves me. He now says that he wouldn't let anyone harm Norbert. He gives him his best wishes during Christmas and kisses him on the cheek. Norbert bribes him with gifts. Dad says that at Christmas this is what he's waiting for. He unwraps the gifts and takes them to the kitchen. He loves technology. He was beside himself with joy when we bought him a portable hard drive. Recently, we bought him the new edition of the *Tytus, Romek i Atomek* comic books.[3] When he got a bottle of vodka in the shape of an AK-47, he showed it to all his friends. Mom calls us every year to let us know what he'd like for his birthday, and we buy it. When Norbert and I argue in front of my parents, Dad often defends Norbert, saying that I exploit him. I think that he's gotten used to us throughout all these years. I'm sure Mom gave him a choice—either he's with me and gets to keep his family, or else he'll end up on his own.

[2] In Polish, the two words are very similar: pedofil and pedał (an offensive word for a gay man).
[3] A comic book series extremely popular in Poland from the late 1950s until the late 2000s.

Błażej Goliński

I usually go by Gosia, only I find it hard to call myself that in front of strangers, to open myself up and say what I really think. Friends who learn about my femininity keep addressing me as Błażej, but after a while they get used to it. I know that there's still a dissonance between what they see and what they hear. I don't know how to change my voice and speak like a woman. If someone knows about me, they probably find it easier to be in my company, only you can tell by their eyes that they're confused.

When I was seventeen, I wanted to go through a complete transition, but I backed out after about six months. I have remained a man who sometimes assumes the role of a woman. I don't derive sexual satisfaction out of it. I am simply fascinated by femininity, feminine rituals, and how perfect they are. I'd describe myself as a connoisseur of femininity rather than as a cross-dresser.

I don't subscribe to the LGBTQ community. It's a group concerned with sexuality, with sexual orientation. Cross-dressers go through something else entirely, but they've been thrown into the same bag. Because of that confusion, we aren't socially accepted.

I would dress up when I was a child, as any curious child would. In elementary school, I would dress up whenever I was home alone. Socializing with people, hanging out in bars, meeting with friends came later, when I was fifteen or sixteen. I put a lot of thought into it. I would plan where to go, the route, the time. At first I thought that people would notice me, but it turned out that everyone was too preoccupied with themselves. And even if someone did look at me, it was like they were looking at a regular female passer-by. I knew a few tricks that would let me go unnoticed. For instance, each time I passed someone in the street, I would suck in my Adam's apple.

I tried to talk to my mom before I told anyone else. I thought she would understand. She brushed me off. I waited two years until the subject came up again, when I felt I needed to transition. My mom, dad, and brother all tried to make me abandon that idea. My dad cares so much about what other people might think about him. That's what bothered him most about my decision »

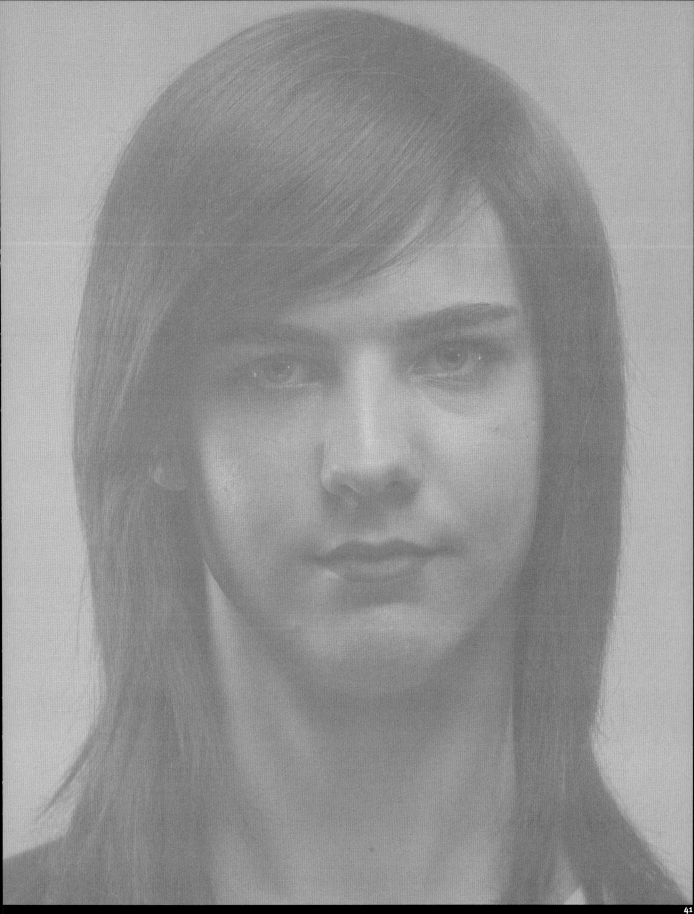

to transition. He was a hockey player. He had dedicated his whole life to this sport. He was proud to have two sons and had never thought that one of them would become a girl. My older brother is a [football club] Legia Warsaw fan. He says that whatever happens, he will stand firmly behind me. My mom knew when to say, "Stop and think." My grandpa was still alive then, and my mom was worried that if he found out, he would have a heart attack.

In the end, after my first consultations with doctors and after a series of psychological assessments, it turned out that I might later regret the decision, so I decided not to transition.

I live with my parents. I have my own closet. Nobody looks in it. My parents have no idea of my needs. They have left me to deal with them on my own. They don't interfere with my life. Once, after a huge argument, they saw me dressed up, but they refused to look at me directly. They would only look at me out of the corner of their eye as I was leaving the house.

I used to read a website for cross-dressers, but I stopped after a while. There were threads that started: "I want to go out dressed up, but I'm afraid." This isn't the right place to start. For me, the real questions are why are you going out and who do you want to spend your time with? Those people live in a fictional world. They share made-up stories and later complain that it's impossible to live in Poland. They think that they'll be beaten up right away. But if you talk with your friends honestly, communicate with them in a natural way, tell them that to go out dressed as a woman on a Sunday night is nothing out of the ordinary, then nothing bad will happen. Even my male friends who enjoy the most typically manly activities would say, "I get it."

My girlfriend and I have been together for two years. We have ambitious plans for the future. She found out about me by accident. She saw my old text messages and read a conversation I'd had with my friends about the transition I'd planned. I asked her what she was going to do. She said that we would deal with it, and I think we're doing great.

I'm twenty-five. I was born in Silesia, in Zabrze. It's been two years since I started transitioning. I feel better now, and my personal life has improved. As for the rest, there's still the discrimination to deal with.

I knew early on that something was different about me. When I was about ten, I would fall asleep praying that I would wake up as a girl, and in the morning I would open my eyes deeply disappointed. I took my mom's clothes when she wasn't looking. I wasn't very girly. I had teddy bears, dolls, I liked toy cars. I spent a lot of time with my female cousin. In middle school, I read magazines like *Motor* or *Car World*. I repressed my feelings for many years. It was only in grad school when I started to realize what it meant. At first, I wanted to make sure I wasn't crazy, that I wasn't making the wrong decision. Later, things gained momentum because I couldn't bear being in the wrong gender. It's as if you're living behind glass, cut off from your real emotions. There comes a time when you start transitioning and begin to bond with yourself, a self you didn't know before. You begin to feel alive. Someone said that it's like you've been using the wrong type of gas in your car and then one day you put in the right type of gas and everything starts working better.

I wanted to buy a dress for myself and asked my mom to help me choose. She asked me if I was insane and if I wanted to be a woman. I started crying. She understood. She supports me. My father at first was neutral about it, and then he had a negative reaction. I don't have any support from him. Our contact is limited. Being in their company is toxic because they have a problem with alcohol. For me, there's only negativity there. My mother, even though she cares for me, is blackmailing me emotionally. My father is my father. When he drinks, he gets aggressive, verbally. Mom was a chief accountant, but she's been living on benefits after her glaucoma surgery. My father is a carpenter. He's an alcoholic. His »

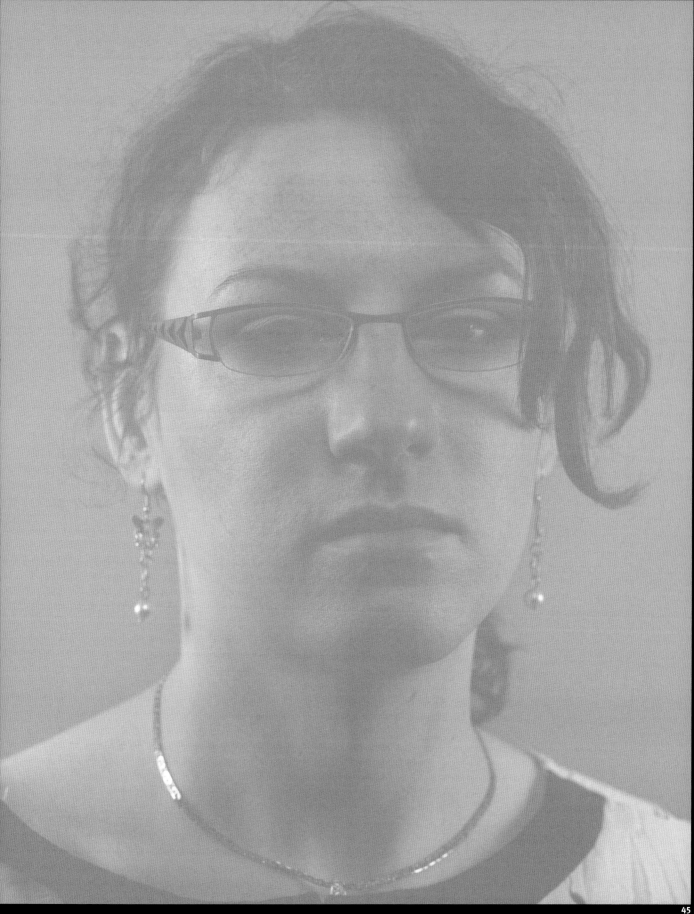

addiction doesn't let him work regularly and earn an income. Mom sometimes drinks with him. My brother has his own issues with aggression. He's insulted me, hit me. My being trans is an excuse for him to humiliate me.

I was aware of what I looked like. I started wearing more feminine clothes to feel better. I started wearing colorful clothes. I began hormone therapy. I was working as a mail courier. When more and more people would address me as "ma'am" when they saw me for the first time, I decided to let people at work know that I was transitioning. The area where I live is not very wealthy. We live on the city outskirts. There's a shady neighborhood not far from us. It's there that a young *dresiarz*[4] threatened that he would beat me up. I'd already been wearing female clothes. He said, "Don't stare at me, faggot!" as if I found him irresistibly attractive. This is what homophobia is about; they think that they're being treated the same way they treat women.

I moved out in January, after an argument with my parents. At first, I lived with my grandma, then an uncle let me stay in his empty apartment. He and his wife are very religious. He wanted me to pay 600 zloty per month. I didn't earn that much, and I had to go back to my parents. After yet another row, I filled out a Blue Card.[5] The police officers kept referring to me as a man. They suggested that my parents throw me and my brother out of the house. At the precinct, the woman who was taking my statement also treated me as a man. She said that this was what the documents said and this is what she had to identify me as, as if I were a piece of paper. You can have a breakdown after an experience like that. I had suicidal thoughts. I started having panic attacks. I asked the family physician if she could prescribe something for a nervous breakdown. She gave me a referral to a psychiatric hospital. I was there for a month. It was a good decision. I went through therapy. Antidepressants helped, too. I can function normally after I take a handful of medications in

[4] *Dresiarz* refers to a subculture of young men in Poland that emerged in the late 1980s. Stereotypically, dresiarze wear tracksuits, have shaved heads, and often swear profusely, and their aggressive behavior usually inspires fear among sexual and ethnic minorities.
[5] A special procedure that defines a set of measures for the police to deal with complaints of domestic violence.

the morning. I went from one doctor to the next. I worked out my issues about my transition, and I went to the Lambda LGBT Safe House in Warsaw.

My problems with relationships have been astronomical. All contact stops when I say that I am trans. I get in touch with people online. I don't go to parties. I don't have too many friends. I'm interested in women. I've met a woman here at the safe house, but it's not going to lead to much. I'd like it to, but she has her own issues. She's not very mature. Tomorrow I have a date with a woman I met on Tinder.

I look like a woman now, but it's still difficult to find work. I was studying at the Silesian University of Technology. I didn't finish, because I couldn't pass one of the courses and I couldn't entirely see myself having a career in mechanical engineering. I'm good with computers, but when I show my documents and forget that according to them I'm not a woman, all I get is rejection. Recently one employer frowned and said, "We'll see how you work. Just don't show off." I did a one-day work trial. The following day I heard that I had poor communication skills and he couldn't see me in this job. But he paid me well for those two days.

It's difficult to find a job that would allow me to live in Warsaw. I'd like to go to England to take care of the elderly or people with disabilities. It's supposed to be hard work, and I don't doubt it. I could earn money for the surgery and a psychology degree. I dream about studying psychotherapy. I'd like to help other people. I've been through a lot. I have lived experience. I've absorbed knowledge from psychologists like a dry sponge absorbs water. I find that I fit the role of an amateur therapist. I'll try to pursue it, but I need documents to hide the fact that I am transgender to protect myself from discrimination. Right now, for other people, I am either a transsexual whore or a bisexual dyke.

I am an older gay man. I'm almost sixty-five.

Young people find it hard to believe that public restrooms used to be our only social space. Public restrooms, including college restrooms, used to be the main gay hangout spot all over the world. In Poland, in the Polish People's Republic, students and faculty members would go there to meet new people and take care of "other matters." You would notice when someone was taking a while at the urinal, playing with himself. The old design made it easy to make connections. The new restrooms don't really allow that anymore. Besides, now there's the Internet.

I discovered that I was gay rather late. I liked boys in high school, but I didn't explore my feelings any further. I used to have girlfriends, although those relationships didn't amount to much. I came out in the seventies when I was in grad school. I was seen as a curiosity, but I felt proud of myself. I read about artistically talented gay men. I never felt that I was worse than other men. I was surprised when I read an autobiography of an older gay man in which he admitted that he felt like a piece of meat, deprived of all dignity.

My father worked in the Polish embassy in London. We moved there for a few years in the early seventies. I studied physics. A gay movement was emerging in London around that time. At college, a gay student club organized its first meeting. I had the urge to go, but I didn't because my father was recognized in diplomatic circles. I knew I would encounter the British Security Service, who would be observing the gathering. I was very careful. After I returned to Poland, I found out that people were gossiping about my sexuality. How did people know? Most likely from intelligence leaks.

In the eighties, when I started teaching English at a university in Warsaw, I told students about the gay movement in America and pride parades. I saw they were nonplussed. A week later, the vice rector summoned me and cautioned me against talking about the superiority of gay relations over other relations. He wasn't rude. I remember him smiling. »

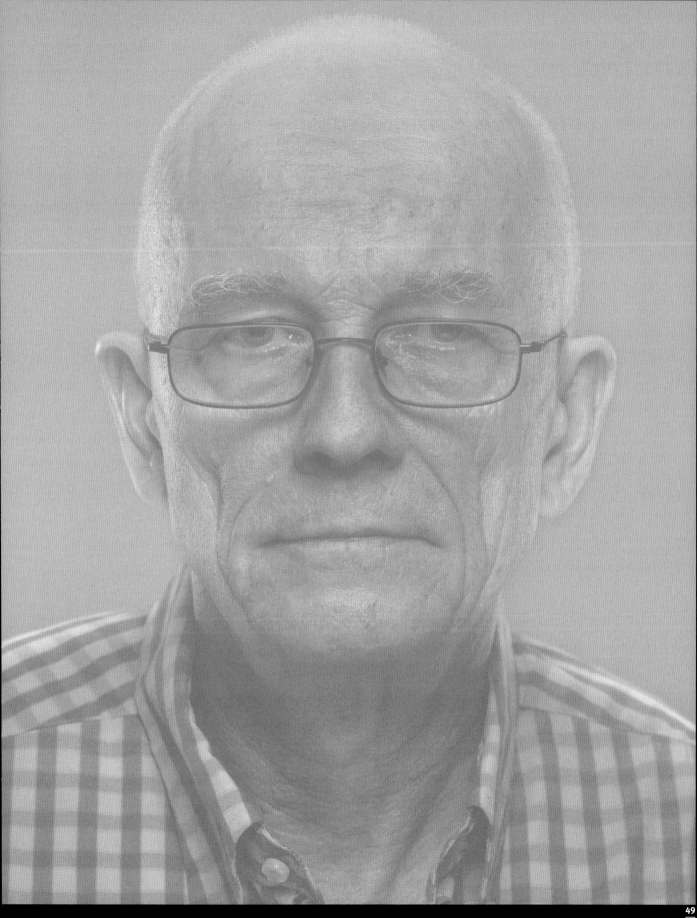

I know which students are gay. Sooner or later they come to see me during office hours. They start talking about academic issues, but they soon switch to talking about being gay. They read about me on the Internet, and we run into each other during events, festivals, or in gay bars.

I am an only child. My parents were worried that I didn't show much interest in girls, but I always had a female friend around me. In the late eighties, I started having a relationship with a woman. Her husband had died early, and she had two sons. I moved in with her. She knew that I was gay. The London gossip had reached her because our parents were friends. She might have thought she could change me. She sucked me into the family life. At first, it was nice. I had my own life and friends in the artistic and literary worlds. She was intelligent. But her approach to the world was different. Literature wasn't her thing. Then, gay life started becoming more and more visible in Poland, and I became part of it. She got irritated. My dog provided yet another reason. I had a wire-haired dachshund. He suddenly became very aggressive toward her. He would attack her in bed. He wanted to sleep only with me.

My parents knew I was gay, but they also didn't quite like it when I was with that woman. There were a lot of contradictions in their thinking. Maybe they didn't like her, or maybe they were bothered by the fact that she already had children. My mom saw gay books at my place but didn't take that seriously. She thought that I wanted to be different, that I was telling myself I was gay. Soon after, a student moved into my apartment. He is more than thirty years younger than me, and we have been together for six years. I think that his mother knows about us and that she's happy because she can see that he's made a good life for himself. We can't be entirely public about our relationship because of his teaching position at the university. I don't want people to think that I had something to do with it.

My neighbors know that I have a boyfriend. Only one stupid woman whose husband was a boxing coach told me that I should find a girlfriend. A lot of people don't see what's right in front of them. I want to have normal relations with people around me. Being gay is not a category. There are many different gay men—intelligent, boorish, mean— much like in any other group.

I'm open about my sexual orientation. I describe myself as bisexual. I've had a boyfriend, I've had a girlfriend. I often get annoyed by questions about my sexual orientation because I don't believe in sexual orientation. The LGBTQ community is divided into men and women. When I go to a gay club, I see men socializing and women socializing, but they don't mingle—they don't dare cross that boundary. If you focus only on finding a partner, you don't have much space for anything beyond being gay, lesbian, or straight. I want to see things more broadly.

Recently, my friends and I went to Warsaw to take part in the pride parade, to help organize the march. We were helping on one of the floats. It wasn't too noisy, but when I woke up the next day, I'd lost my hearing in one ear. I thought, "It'll pass soon," but it didn't. I went to see a physician. The parade was starting in three hours, and the doctor said that I had to go to the hospital for tests. I didn't want to miss the parade, so I put some cotton balls in my ear and went to the parade. I went to the hospital afterward, was treated, and regained my hearing, but for a week I went in for tests. They were checking to make sure I didn't have cancer or some kind of tumor. Two nurses were taking care of me. One was a conservative. She would talk to me about her daughter, who wanted to move in with her boyfriend before getting married. She told me that there was a man in the same ward who, like me, didn't eat meat. That made me happy. "I have to meet him!" I said.

She replied, "Don't. He's Muslim." I wanted to meet him even more. The next day, we passed the Muslim man, and I said, "He's cool." She got angry: "Stop it. He's nothing special." I talked to him a little. Then, the nurse said to me, "Leave him alone. He has a wife and a child, and you, do you have a boyfriend?" I looked at her with a smile on my face and she kept asking, "Well, do you have a boyfriend?" I said, "No, but I might have a girlfriend." "Oh, stop it. Really? And your parents are fine with that?" She was asking all these questions while standing over the bed of a patient who still hadn't woken up from surgery. When I was leaving the hospital, one woman in our hospital room said, "I know some lesbians. They're cool. Everyone's used to them now."

My parents know that I've had a girlfriend, but my grandma doesn't. I haven't seen my more distant relatives for a long time. It's not that we don't get on, but I avoid big family gatherings and holidays. I hate Christmas Eve, when there's over twenty people at my grandma's place. At the table, somebody will always use the word "homo" or tell a crass homophobic joke. I react, I say things, I get angry because I am an activist. My family accepts my views. When I say something, nobody argues. My parents know that I don't like those gatherings, and they respect that. For Christmas, they wish me good health, happiness, and that I will finally find a good boyfriend. I don't know how to tell them, simply and naturally, "I prefer women."

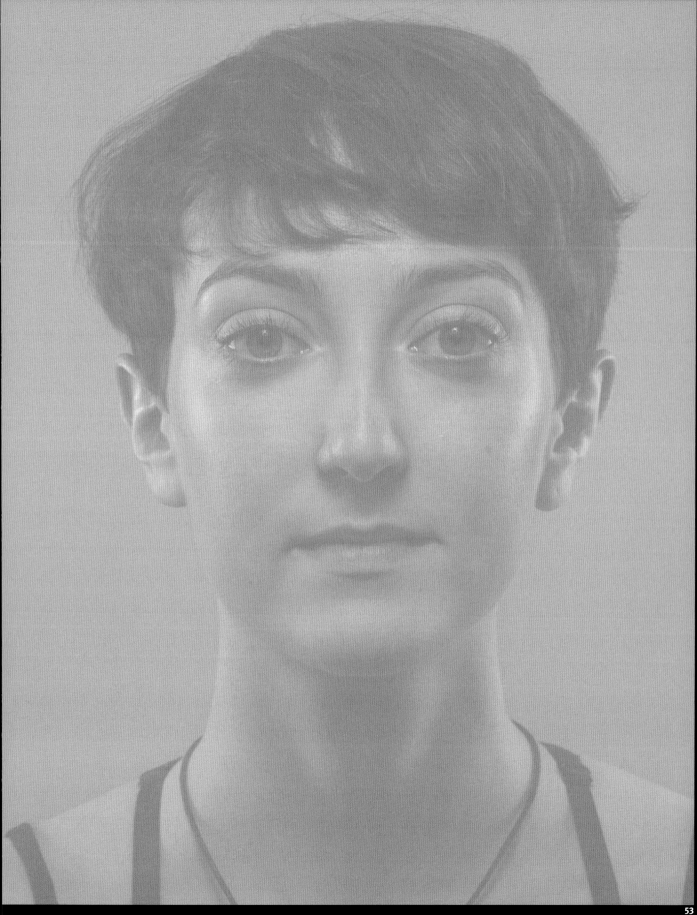

I chose to live in Warsaw because living in my hometown in Lower Silesia would have been tough. I never told my mom that I prefer women, but her new partner guessed it. He said that since I never had a boyfriend, since I had a boyish style, and since I left to live in the big city, I must want to be with my own people. Compared with my twin sister, who is very feminine, I am masculine. We are identical twins. We get on very well. My sister knew from the very beginning. Sometimes, she would joke and introduce me as her brother. My hair was short, and people would refer to me by a male name. I remember a classmate asking me if I was going to have a husband or a wife. My sister thought that it would pass. Now, at twenty-five, she's accepted who I am.

A year ago, our mom asked her if I preferred women. My sister said I did. Mom said that she didn't understand it, but that she still loved me because I am her child. I wasn't supposed to know about that conversation. I pretend that I don't know that she knows. I think she doesn't know how to talk with me about it. She assumes that I'm single. She's left me alone and doesn't ask me about my male friends. I visit her once every few months.

I didn't cope well with puberty and becoming a woman. I would hide my body under baggy clothes. When I wear a loose shirt, I would hear people walking behind me wonder whether I was a boy or a girl. I wouldn't turn around. I wouldn't react. A few times on the bus, when I was wearing a down jacket and skinny jeans, I was called a faggot. In a shopping mall, one girl said to another, "It's a girl, but she looks like a dude." I don't agree with rigid divisions. It's sexist to assume that once a baby is born, you can map out their life—their looks, their gender, their sexual orientation, their relationships with others. I think that our education needs fixing. You are not taught at school about sexuality, that there are gay people, that diversity can be good and enriching. If someone is different, they're forced to keep silent about who they are.

I'm always going to talk about it more openly with some people and less or not at all with others. I don't like coming out. Usually someone asks, "Is it true, Natalia?" And I say, "Yes, it is." I'm afraid to talk about myself. It might be due to an internalized homophobia. My guilt and embarrassment are a reflection of society's attitudes toward sexual orientation. »

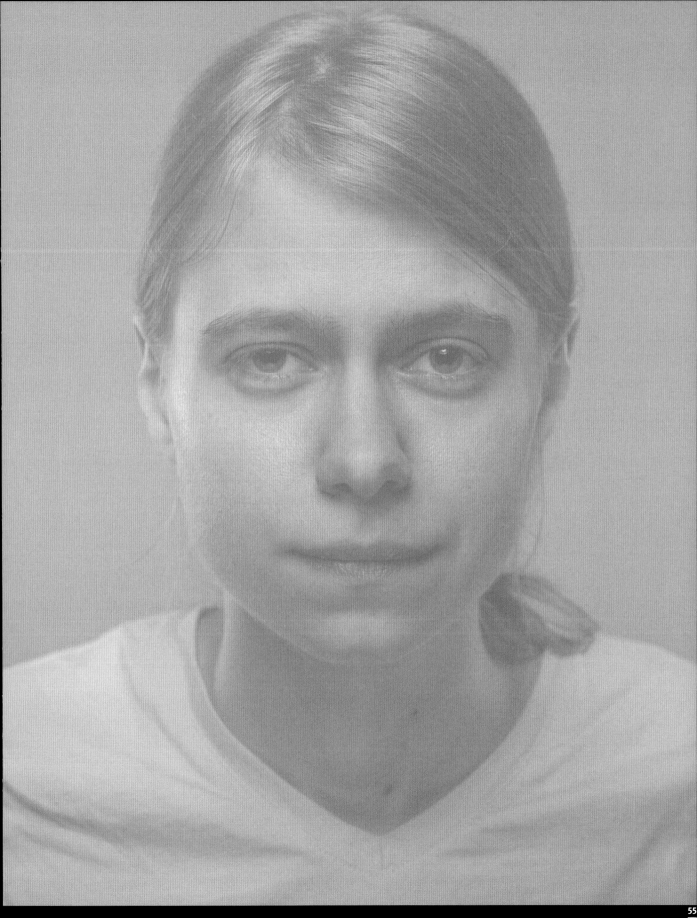

I think about who I am every day. I am careful. I don't talk about it if nobody asks. I try to feel people out. If I see that someone holds liberal views, I talk about who I am, but if they're right-wing, I don't. Encountering new people always makes me confront my own identity. I notice the differences: this is who they are, this is who I am. When my female colleagues talk about men in the breakroom and want to know what I think, I say that I'd rather not discuss it. They see that I'm not interested in their world, that I'm not part of it.

People at work have talked about being gay in a general kind of way. Those conversations didn't concern me directly. Nobody asked about my sexual orientation, but the news spread. Nobody insulted me. They tried to get used to it. The worst I heard was that it wasn't natural. This is what society thinks. I think that my presence shows people that a lesbian can be nice, that you can talk with her about various things, that she can give good advice.

Gay men are more visible. There are more gay clubs than lesbian clubs. Maybe women are more cautious in public. It might also be that the gay male body is more appealing. In *Replika,* an LGBTQ bi-monthly, all the ads show muscular chests and low-cut shorts. You won't see similar ads with women. The gay male body is highly sexualized. The image of the gay man is a man who's stylish, smells nice, and earns a corporate salary. *Replika*'s editor-in-chief puts the prominence of gay men down to there being more men in the LGBTQ community than women. I think it's because Poland is a patriarchy. Maybe the time has come for queer feminism.

It's difficult for me to find someone. I'd like to have a long-term partner. I'd like her to share my views, my sensitivities, my temperament. I'd like us to have shared interests, to act for social justice, to go to protests. If we were good together, we could adopt a child. A girl. When I see little girls, I immediately feel I want to care for them. I still believe that I'll find that person. That hope sustains me.

I come from a village in the mountains. I left ten years ago. My friends who stayed there started their own families. I'm not saying that they made the wrong choice, but I wanted a different life. First, I lived in Ibiza, then I moved to Warsaw. At that time, life in Warsaw was already much more free. I managed to move in with people who were tolerant and understanding. I was in therapy, getting used to being gay, trying to acknowledge it. If you're rejected by different parts of society—the family, the village, the nation—it's more difficult to live with it.

My grandma was the first person I told I was gay. She didn't know what to say, but now, she's my best friend. She is deeply affected whenever I break up with a boyfriend. She is seventy-eight years old. As for my father, he called me himself to ask, not whether I was gay—he can't actually say the word—but whether I had chosen "a different option." I said, yes, I had. He was upset for two months, but he eventually got over it. Now, he wants me to talk to him as often as possible.

The essence of therapy and of working on yourself is in rebuilding the relationship with one's family. This is what's ahead of me. I'm going home this weekend to talk with my parents, not about how hard it's been for me, though maybe I'll mention this briefly, but rather about how important they are to me. I want to tell my father that I had more issues with my being gay than he did. It was difficult to live in our village not knowing what it was all about, without being accepted by my parents. It used be hard, but that's no longer

the case, and I want to show them the path I've traveled along. If you want to come out, it's worth telling people how hard it is to live with it. I've had enough of pretending. I recommend therapy to everyone. This is what I'm known for among my friends.

I used to think that if you're gay, you spend most of your time looking for a boyfriend, and that all gay men do is browse dating apps. But straight people do the same thing. My therapist, who has a big family, explained to me that heterosexual people can be equally promiscuous. And it's easier for them. We have to remain much more hidden. The further west you go, the greater the freedom. Here, the situation is not tragic. East of Poland is much worse. We are in the middle, but it's clear that Warsaw is an exception. The rest of Poland is a completely different story. In Warsaw, you can wear crazy clothes and it's no big deal, but in Gdańsk or in Kraków people will look at you funny or call you names.

I travel a lot. I like to explore the world. I have a great job. When I was in high school, I started to learn hairdressing. I'd always wanted to style hair. Right now I manage a chain of my own hair salons. I want to have a family, and I will, but first I need to find a partner. Whenever I've felt good about a relationship, I've thought I'd like to have kids so I can pass on to them all the great things. I know that if you want something, you can do anything. The law is of no consequence. They can maintain the gay adoption ban all they want, but who will prevent me from having a baby?

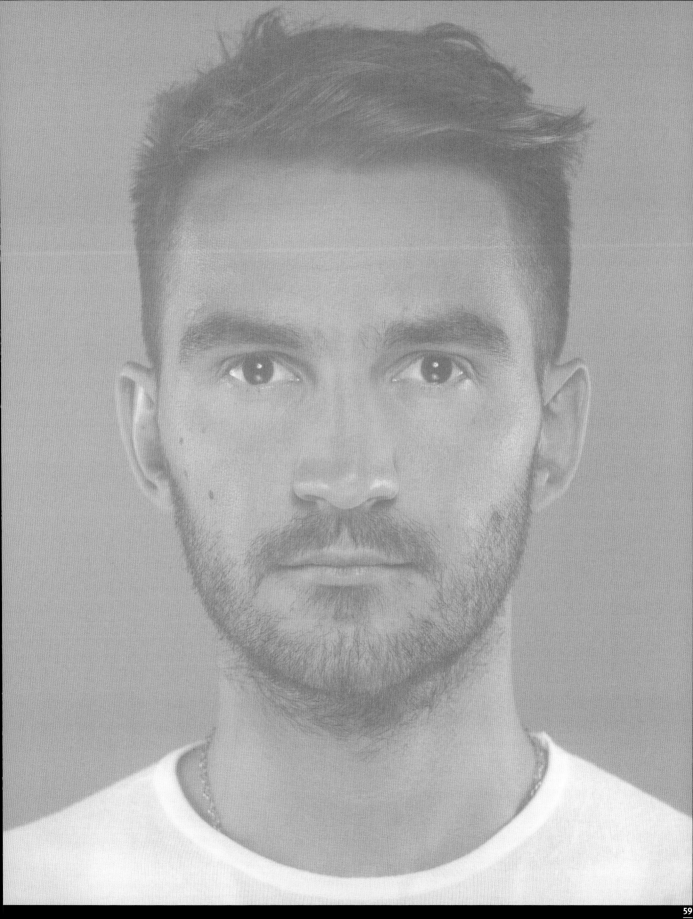

My mom thinks that a gay man is someone who wears black leather chaps and has sex in bushes. That's why she's terrified her son is gay. Maybe she's afraid that people in the street will point at her. My brother, after I told him, said he didn't have any problem with it, but he asked me not to tell anyone in Warka because it would cause a hassle for Mom. My mom is a hairstylist. In the salon's glory days, people would recognize her in the street. She knew the mayor and the local "celebrities," which made her think she was a public personality. She could get things done. She would help people. She had worked hard to earn her reputation, and maybe she was afraid that people would say she had failed as a mother.

I remember from going to church when I was a kid the priest talking about gay people. I knew it was all bullshit. I had a brain, and I had read the Bible, which says that God loves all people equally, regardless of what they do and how they do it. Why should I believe some old man rambling away and putting people to sleep from his pulpit?

I had been planning for a year before I told my parents. It took a lot of effort. I went to therapy. They had their suspicions. She wanted to believe that there was hope, that I would give her grandchildren, like my brother, who had started his own family. In theory, there's no reason why I can't. Maybe Polish law will change and gay couples will be able to have children legally.

When I came out to my parents, I felt like I'd been preparing for it for ten years, ever since I was certain that I was gay. I called and said I was coming. Dad promised he would pick me up from the train station. He asked if we were going to start with dinner. I said that what I had to tell them would be hard and we would have all lost our appetite by the time we'd finished talking. We hung up. Mom called me a minute later and asked why I was only coming for a short time. I explained that I wanted to talk to them, that it was an important conversation that I wanted to have out of respect for them. She kept probing the subject. She suspected something. She asked if it was something that would give her a reason »

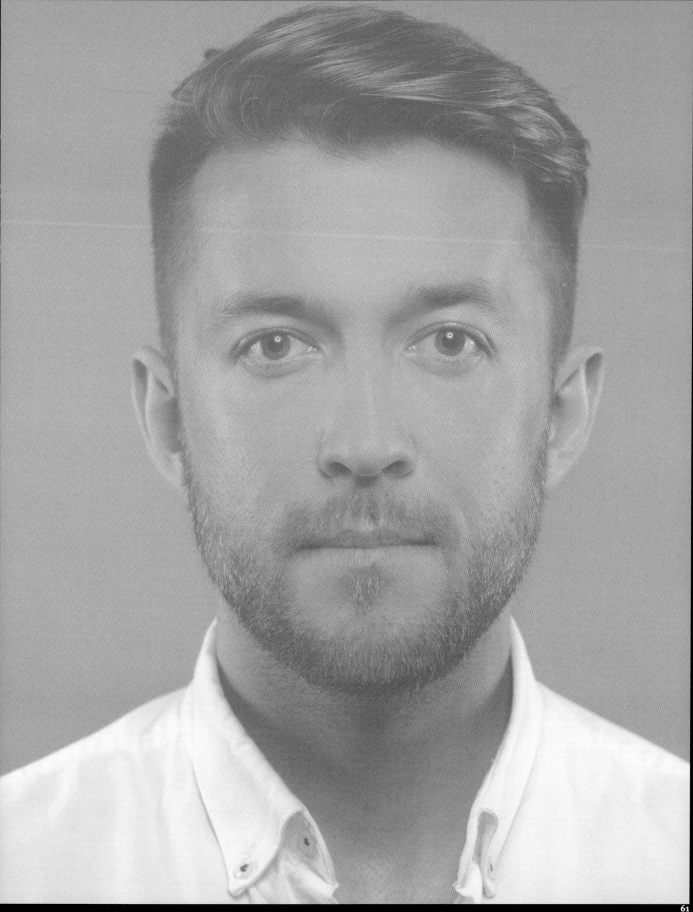

to disinherit me. "If you mean me being gay, then yes, this is what I want to talk about," I said. I heard her cry. I was ready for that. I knew this was her strategy. She thought her tears could convince me not to be gay, as if it were a matter of my deciding if I was gay or not. We argued. She said she had given her life to me, that she had tried so hard, that she didn't want to have a son like this. I said, "There are some things from my childhood I have reservations about, but I also remember a lot of good things and I want to have a relationship with you. I'm Patryk, the gay man; Patryk, the working man; Patryk the man who goes to parties and who sometimes has a hangover. I want to be myself. I want you to see that I am normal." None of it got through to her. She was shocked. She was still crying, and when I said that her tears weren't working, she stopped immediately and became aggressive. We hung up. Dad called me a short while later. He asked if I wanted to talk with him. I said I did. He told me not to come. I asked if he, like Mom, thought that this was something to be cured. He said yes.

I finished our conversation by saying that I hoped that one day they would educate themselves and that we could meet again. He called me again the following day, when he was alone at home, and we had a normal, calm conversation.

It was a difficult discussion. We have not talked to each other for two months since then. I tried to approach them with care and understanding. After all, it's difficult information to process for orthodox Catholics. They're elderly, over seventy years old. They go to church, and they're active in the Catholic community. In their eyes, I'm sick, possessed. I intend to get back in touch with them—maybe a letter, maybe a phone call in about six months.

For many years, I was against same-sex adoption. I was thinking about the well-being of a child growing up in a country steeped in homophobia. I could imagine the child in kindergarten being called names by other kids and teachers because they had two dads. Young children see their parents as a beautiful painting, and here you would

have someone suddenly throwing ink on that perfect picture by saying, "Your parents are bad." But in the Netherlands, children adopted by same-sex couples are talented, are artistically inclined, they're independent, and they can be straight. If it's working in the Netherlands, why shouldn't it work here? Awareness has been growing in Poland, but in order for same-sex adoption to become legal, we need political change. The current government doesn't even protect us from abuse and discrimination even though we are citizens of this country and we pay taxes.

I am a manager at a designer furniture store. I work with people a lot. They know I'm gay. Only one man was concerned that I would try to pick him up. I asked him if he was straight. He said he was. "Since you like women, does it mean that every woman in the world should be afraid of you because you want to make out with her?" He started going through the types of women he didn't like. I said, "There you go. Gays also have their types. You're not one of mine."

I recognize gay people by their gaze. We look at each other longer if we're interested in each other. But there's also a tension between us. If you're not reconciled with the fact that you're gay, then coming across a gay person who is and who strongly presents as gay makes you afraid they might recognize that you're gay. So you do everything to ridicule that person or to separate yourself from him. You might, for instance, become a gay nationalist with swastika tattoos. I know a person like that. He goes to nationalist marches, throws a Molotov cocktail into the crowd, while as a gay man he comes across as good company and a nice guy. A lot of *dresiarze* are gay. A lot of them are in the closet.

I've recently been thinking about whether I should start anew, in a new place. Somewhere, like in Spain, where straight men can express their feelings toward each other. They can embrace or hug each other because they're united in their fraternity.

I knew, from preschool, that I liked women. I always knew it but I didn't realize that sex between women was technically possible. Today, women laugh at me when I tell them that. "You have no idea in how many different ways," they say.

I was born in Vienna. My mom is Austrian. I studied there, and I could have spent the rest of my life in Austria, but my family and I came to Poland. My sister emigrated to the United States, and I stayed with my parents. Austrian society is great. People would ask me: "Do you have a boyfriend or a girlfriend?" It was a society where nobody was surprised by different sexual preferences. But I've chosen Poland. I'm not sure why. Maybe it's something about the Slavic soul. We Poles always fight for something. We become united in a fight. An idea emerges, strategies for actions develop, and I have to say that this life is more interesting than the boring Austria that has already figured out everything.

Society pressured me to find a man. I emphasize the word "society" because my parents are pretty liberal. What's funny is that they vote for the Law and Justice Party, but they never pressured me, they never told me who I was supposed

to be. It's my fault, too, that I ended up being squeezed into making certain choices: a man, a child, a mortgage, an apartment, grandchildren. You know what your life is supposed to look like already when you're ten; it's only with time that subordination can become unbearable.

Eight years ago, I met a woman. I spent five years with her. I lived completely in the closet when I was with her. I'm surprised as to why I did that. I didn't want to come out even though she kept asking me: "Let's talk about us. Why fight it?" For me, there was no way around it. I've only told my mom; my dad has known just for a year. He's more conservative. He asked me about Agata, my ex-girlfriend. She spent a lot of time with us. It was never explicitly stated that we were together, but when we broke up, he wanted to know what had happened, why she had disappeared. I told him while he was eating dinner, and he didn't even choke. When I finished, he said, "Thank you." You imagine there will be an explosion, that the earth will part beneath your feet, that you will be humiliated, or that words will be said that will divide the family. But nothing like that happened. Sometimes it's much easier than a hundred other things we do every day. »

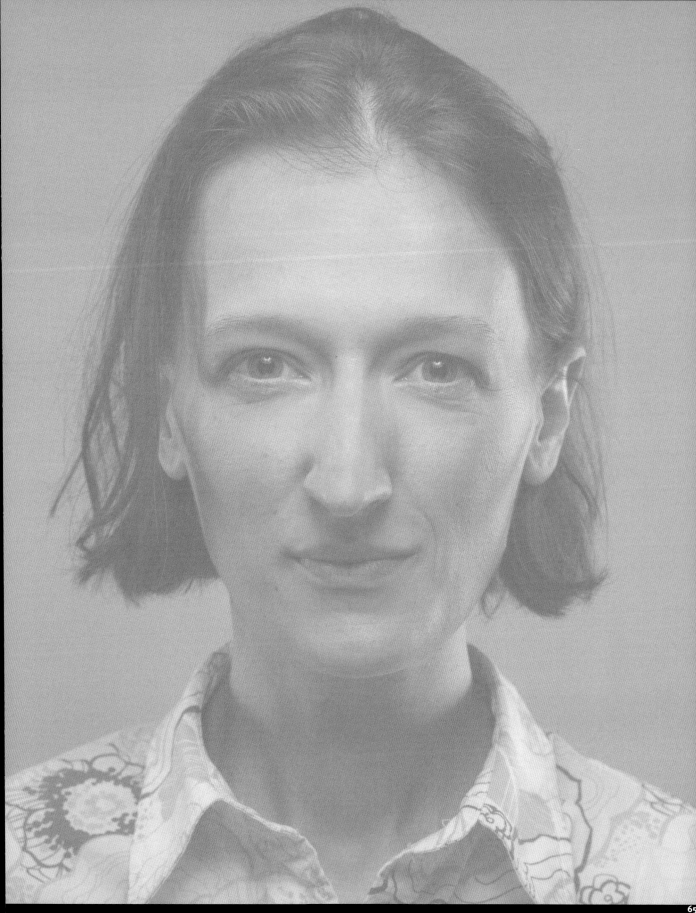

Hiding the truth was my biggest mistake. Because of my silence, our relationship fell apart. After that, I realized that I didn't want to live like that anymore, that I wanted to go full-out. I went to a party. I met a girl whose hairstyle gave her away as a lesbian and said, "Are you a lesbian? Me too. Let's talk." It was impudent, and I did it to break that silence, to enter that community. My life changed that day. The girl introduced me to others. In a year, I met a few dozen lesbians. I knew right away that this was my place. It's as if you've moved to a new city where you immediately feel great and you know that this is where you want to spend the rest of your life. This is what I've always been looking for. We always have something to talk about, and I can be who I am, and I don't have to talk about men, which is something I've never been interested in. I used to force myself to listen to my female friends. I feel like I've been born again.

I wonder why I'm so worried about the opinions of people I don't know—my neighbors, for example, who I pass when I walk my dog. Tradition, religion, habits are deeply rooted in this country. I've traveled a lot, and, unfortunately, I have to say that Poles have many hang-ups. They shouldn't. They don't understand their potential. Like,

ideas flare up in this country, but we still think that the West is better than us. Poles are afraid of difference. When they feel threatened, they prefer to stick to what they know. It's tunnel vision. I blame tradition and religion for this kind of thinking. In Austria, conservatism doesn't go hand in hand with homophobia. Conchita Wurst is an Austrian phenomenon. I've watched documentaries about her, and I see that her parents still live in a small Austrian village, deep in the woods. They wear traditional local dress, and they are proud of her and of what she does. They are religious, but in a different way. A lot of Protestants live there. Their pastor said that it's in the church's interest to let a person grow, to discover who they are. We approach it very differently. I feel like what the Polish church says is completely different than what the Catholic Church says outside of Poland.

I was recently at a conference where the results of a Polish study were presented. Heterosexual couples had been asked whether they supported civil unions for gay couples. Support was greater among people who knew at least one gay person. This proves that you have to come out and talk about it.

The whole world is framed by heteronormativity. There's a girl, and there's a boy, and there's a family—the fundamental social unit—and this family has to be protected and defended, even if it turns out to be abusive. You must also attend Sunday Mass and obey the priest as if he were the most important person in the world.

For me, the priest *was* the most important person in the world. I was a deeply religious practicing Catholic. In grade school, I attended Advent Mass every day, May Devotions, and prayed the Rosary. I liked the church and its atmosphere. In high school, religion was taught by this fantastic priest, a wonderful human being. He organized all sorts of activities for us, like taking us on spiritual retreats. At my eighteenth birthday party, he showed up dressed as Batman, although he left around 10 p.m. because everyone was already tipsy and he didn't have anyone to talk to. From time to time, he liked to surprise us. There was a quaint post-war church in my hometown. I remember he invited us to visit. The candles were burning and there was a kneeler with a Bible on it. We could sit down wherever we wanted, and whenever any of us felt like reading a passage from the Bible, we would approach the kneeler, open the Bible, read from it, and return to our seat. It was magical.

At that time, I began to have strange feelings. I knew that I wasn't myself when it came to boys, but I continued to date them just like my female friends did. I was curious about these feelings (I guess this is how people are drawn to cigarettes or alcohol), but as a young woman, I was conflicted. I thought there was something wrong with me. On top of that, the church I belonged to and where I felt at home said that I would be punished for being with a woman, that it was a sin I had to confess to and repent for. When I was a student, I sought an opportunity to talk to a priest, any priest, about this. I went to confession, and the priest who heard me told me to talk to the nuns. I didn't feel like pursuing the issue. I was looking for help among people who kept telling me that I didn't belong. I knew that I had to seek help someplace else.

In my hometown, I was the first out lesbian. On the one hand, people kept saying that I brought something new and unknown, something that everyone had been afraid of, to the town, but on the other hand, I was still myself. They had known me before I came out. »

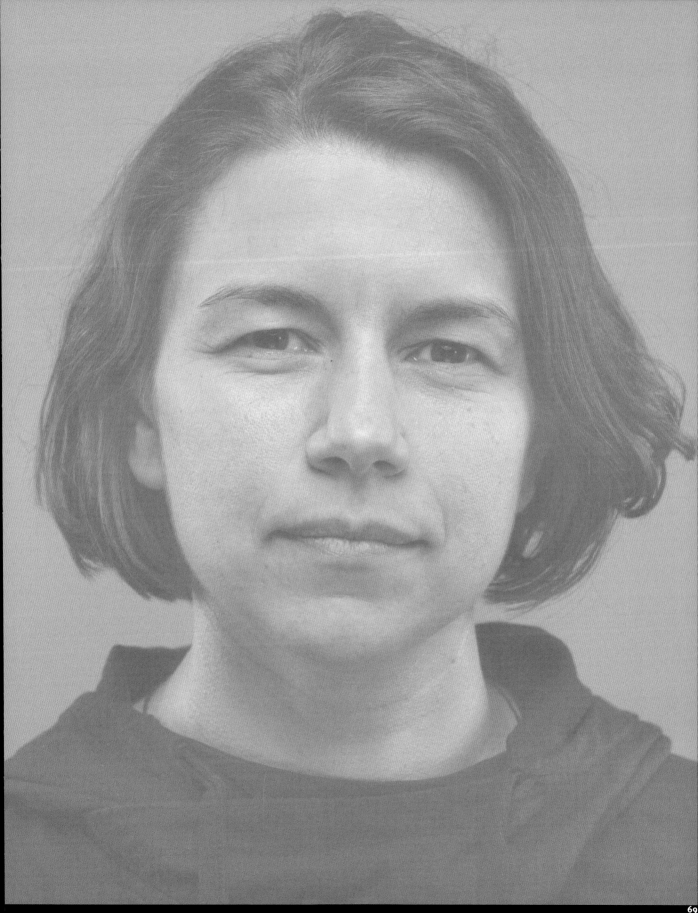

I left my hometown because it was too narrow-minded. Poznań, where I studied, was also suffocating. Imagine: to feel free, you have to live in hiding. Straight people never have to think about that. For gay people, when you go out, you have to wait to be buzzed in to enter a bar. You can't hold your partner's hand in public. Women can get away with it because girlfriends sometimes hold hands, but gay men holding hands in public in Poland? It doesn't surprise me that they are afraid, especially now with the growing confidence of the Polish nationalists.

I don't agree with the current political system, but I don't want to leave. I was born in Poland; I am Polish—this is my culture and my history, and this is where I feel comfortable. I lived in the United Kingdom for three years. Over there, you're just an immigrant, regardless of whether you're a laborer, a banker, or earn a million pounds. None of that matters, because you're not part of the culture. I feel estranged abroad. I have a right to live here in Poland. I want to be here and contribute to its culture. I am thirty-seven, and whenever I visit my hometown and go out to a bar, I can freely talk about who I am. People say that, thanks to me, they have been able to engage with LGBTQ people.

I gave up on the church when I was twenty. I didn't need it to be a good person. There are still great people in the church. Surprisingly, there are even priests who administer communion to gays and lesbians. Also, organizations like Faith and Rainbow bring together gays, lesbians, and transgender people. But I am in charge of my own spiritual life.

It's only with my family that I can't talk about it. Sometimes I feel helpless. I feel like my own family has no place for me. My family can't understand that somebody might feel differently. Next year, my nephew, Maciek, will celebrate his First Holy Communion. My brother said that my partner and I will not be invited because our presence will distract from the ceremony. Instead of focusing on the boy, the guests will fixate on my being a lesbian. He said that I can come as long as I come alone. He remembers what happened at our friends' wedding last year. I'd assumed that since I had been invited with my partner, Marta, I didn't have to pretend that she was just a friend. We danced and hugged and we maybe even kissed, but it wasn't like we had sex in public. My brother later heard that his sister "had showed up and stolen the limelight." I don't know what

to say in moments like this. Part of me wants to say to my brother: "Listen, it's like I'd invited you to an important celebration and said, 'Don't bring your wife because her nose is too big.'" My brother said that this is different, that "I have this sickness." I asked him, "So, you think I should see a doctor and get a treatment?" "Well, no, maybe I exaggerated. But it is embarrassing." Maybe I should simply turn my back on him and say, "Either accept me as I am, or not at all, because you can't accept just 60 percent of me." But I care about my nephew. He won't understand why I didn't come to his First Communion, and he will be hurt, and I can't control how they will explain it to him.

Once, I came home alone for Christmas, but at some point I couldn't take it anymore. I couldn't continue pretending I was a spinster. Everyone would start pitying me again: "Poor Ania, so smart and pretty, but at forty she still can't get her life together." I felt like I was going to choke. I got mad at myself for putting up with it. "This is the last time," I promised myself. Often, your family is fine with there being gay men and lesbians in other families, but if someone close to them is gay—a daughter, a son, a cousin, or aunt—then it's a big problem. I completely don't understand this embarrassment in my family. In the past, I found it hurtful.

Most LGBTQ people don't have a fully accepting family. Of course, that's going to change. The world is changing, and gays and lesbians now have children. But the more you venture outside of the big cities, the worse it gets. People live double lives. They conform to social norms. But, secretly, they try to be true to themselves, often hurting their spouses and children. Often, they can't cope with this double life and commit suicide. Some join the church because they can't bear the burden of their physical desires. Me, I've had enough strength and courage to be who I am. I don't go home for Christmas anymore. I choose who I spend time with, and my friends are my family. Sadly, I don't think that my relationship with my mother is going to change. We talked once, and I said, "If we go on like this, we'll be at your deathbed or mine, trying to forgive each other for missing the opportunity to build a close relationship. Is this what you want?" My mother responded, "It's unimaginable. I won't survive it." That's all she said.

Magda Wielogołaska

I'm thirty, and it's the first time I've felt a coherent and grounded sense of self, which has to do with my sexual consciousness. It took years. Now, I've tasted freedom, and I know what it feels to be yourself, and I'll never give that up. Coming to this realization has been painful, especially in the face of Poland's religious establishment and oppressive society.

I feel that I know the rules of the social game. Choosing a life on the margins means that I can play the game whenever I need to. But, to be honest, I don't want to live in a system where you have to be who others expect you to be—with a husband, with children, attending Sunday Mass, living the godly life. I don't fit these expectations. Besides being a lesbian, I believe in shamanism, which in Poland is associated with Satanism, but in fact it means I'm an advocate of natural medicine and responsible consumption.

For a long time I didn't know that I was a lesbian. This is how strong Catholicism's grasp was on me. My sexuality was in my mother's hands. Her own life had been crazy, so she decided that her daughter had to be pious and pure. Jesus was the number-one priority. She tried to shelter me from things that, according to her, were sinful, but I made my own choices.

My life up to this point involved desperately trying to find out who I truly was. My family's views are mixed. On the one hand, they vote left, but on the other, they are deeply religious. My mom is Roman Catholic, my dad Pentecostal. He was supposed to become a Pauline monk, but he got my mom pregnant and wasn't ordained. I wasn't allowed to say at dinner that I had a girlfriend or, even worse, to invite her for Christmas, but I finally told my mom I didn't want to be referred to in the family as the old spinster with her cat who hadn't been lucky enough to find a man. I also told my mother that I was happy. I lost contact with her after that. My mother is waiting for me to apologize to her and get married. That's not an option. I actually don't mind losing touch with her. That way, I don't have to pretend to be someone I'm not.

In hindsight, I realize that I fell in love with girls when I was twelve. I just thought it was friendship. Later, toward men I acted like a nasty bitch, but it was because I wasn't myself. I'd been in »

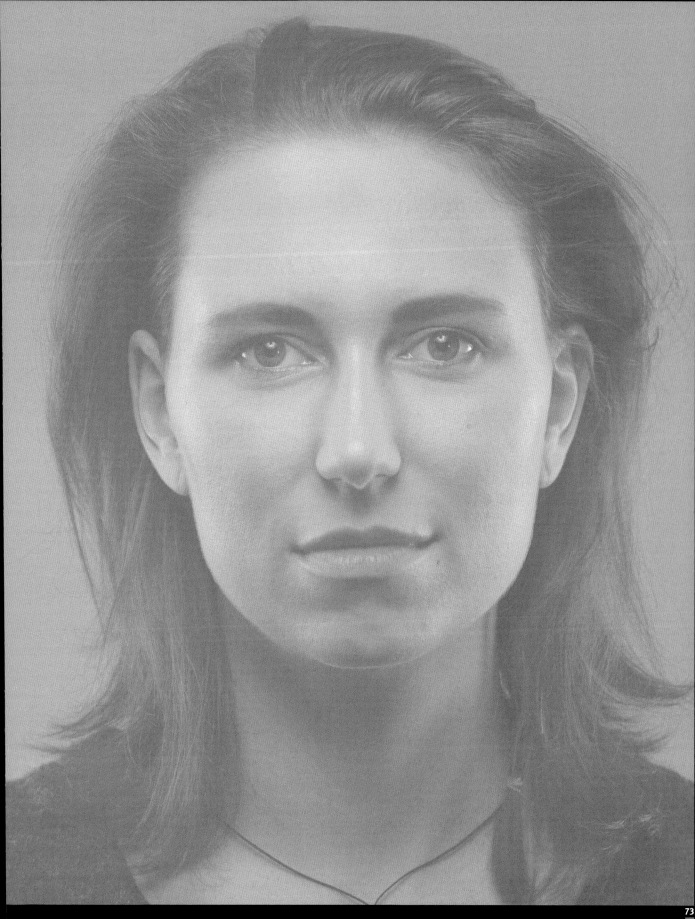

a relationship with a man for a few years when for the first time I had a dream about having sex with a woman. The dream was so realistic and so different from what I'd known that I woke up dripping sweat and thought: where is this coming from? Then it turned out that reality was just like the dream. Everything started falling into place. I took a queer studies course. I pretended that I needed material for my cultural studies course, but I was there for myself, among thirty other non-heteronormative people. For me, it was madness. This is how I met my first love. We decided to move to Gdańsk together. I had a farewell party and invited my friends. I took everyone to one side and told them what happened, why I was moving, that I wanted to live openly as a lesbian. Everyone felt obligated to tell me a secret of their own in turn. A friend told me that he had kissed his sister. Another asked why I hadn't had a relationship with her.

After that, I became more active. I found out what the situation was for LGBTQ people in Poland and how the LGBTQ community operated. It turned out that things are damn hard here, that you have to have a lot of strength to fight for yourself.

There is in Polish society an "our lesbian is okay" syndrome. There is in our village a woman named Barbara who's a lesbian, but she's our lesbian. We know her, we know her parents, they're decent people, we went to school with her. But other lesbians are bad and have to seek treatment.

It's also said that lesbians are usually bike-riding, cat-owning vegans. There is something to that, but I'd look deeper for explanations why. When you discover that you don't fit with societal expectations, you start to ask yourself who you really are—are you a good person or a bad person? If you're strong, you'll start looking for answers. You'll start thinking about what's the best food for you to eat, whether you want to work for a corporation, or whether you want to follow your passions. Becoming aware of how you are different brings other things to the surface. You dig up your own dirt, you clean up your closet, you confront yourself. From this confrontation emerges the need to confront the world, the need to see what you're capable of. In my opinion, gay people in Poland are very self-aware. They're sensitive to the issues concerning the environment, animals, and minority rights.

Masculine lesbians—shaved heads, plaid shirts, the so-called lumberjack lesbians—are the most visible. Those who look feminine are indiscernible from straight women. Here's what happened once to me and my partner. We were at a bar and went outside to have a smoke. A group of nationalists and their girlfriends were sitting nearby. One of them was explaining how to recognize a "real dyke": "She's short, tattooed, with her nose pierced." We listened closely, two tall women, a brunette and a blonde. At one point I'd had enough and said to my girlfriend, "Let's talk to that dude." We were a little afraid because the atmosphere in Poland is what it is. We said a real lesbian looks like us. Their jaws dropped. One of them felt brave and said we look like porn lesbians. I said, "Look around. That woman passing us by, your sister, your friend, your mother—they all could be lesbians, too. Only you won't recognize them because you've assumed that lesbians don't look like real women." Society has no idea who gays and lesbians are.

I once led an event called "Hand in Hand," which involved gay couples walking down the street holding hands. If you see something enough, it becomes familiar, and at some point you take it to be natural. But until we gay people start living normal lives, until we stop hiding from our neighbors, parents, colleagues, that change won't happen. We are still at the stage where the social and emotional cost for us might be big, but we have to do this work. Someone might become more aware thanks to a sign at a pride parade. Someone else might have cool lesbian neighbors, or their daughter might be happy in a relationship with a woman. Another person's father might be gay and not be afraid to say that. Until we start coming out, people will keep treating us as strangers, and because they're afraid of what's unfamiliar, they will keep fighting us, even unconsciously.

As I see it, the only solution is to free non-heteronormative people from the norms that they're used to and that make them withdraw from us. We don't have to hide. Let's show that we exist! The greater the number of people who come out in different walks of life, the greater the chance that society will change.

I grew up in a small village, Borówki, on the outskirts of a national park. Around three hundred people live in the village. It's beautiful, but the opportunities are limited. All my friends went to study in Wrocław, but I chose Kraków. I wanted to study philosophy.

At college, I went through, in some sense, a period of nihilism. When I opted out of religion classes, my mom was furious because she is a deeply religious person, even though she has always voted for left-wing parties. I started taking religion again later and saw the light. I began attending meetings for religious youth. I met a few great people and got into the Catholic movement. I entered the novitiate. I had good intentions, but ultimately I didn't have enough faith. I thought I would become an educator, and faith would come with religious practice, but this never happened. I couldn't believe in dogma. I had two friends in the religious order—Sebastian and Bartek. They left, too. Bartek fell in love with a girl, and Sebastian liked to party. The order is such a hermetic environment that even the smallest things became huge issues. We couldn't accept that, and we left in our second year of graduate school, all giddy from New Year's Eve celebrations in Opole with our female friends.

I don't think I entered the order to escape being gay. When I think back on those days now, I can see that I had my eye on a friend who is now a priest. I fancied him. He had a beard, he was all hairy, he had everything I get off on. In hindsight, I should have paid more attention to the clues, but because of my upbringing I didn't notice. I wasn't paying any attention to my sexuality.

I learned that I was gay only when I fell in love with my first boyfriend. I was twenty-one. Now, it's obvious to me that I must have known, but I only became 100 percent certain when I met him. He was my neighbor in Kraków. A few friends and I knocked on his door during a power outage in my apartment. I liked him very much. We invited him for dinner, then he invited us back. I think he was attracted to me as well. I knew he was gay, or at least I very much wanted him to be gay.

Everything happened by instinct, without reflection. He was fascinating. I got fully involved: text messages, then a long walk at night, and it turned out that, yes, it was happening. I was afraid of how people would react; I didn't know what to expect. I texted my best friend to tell him that I was with someone. He texted me back: "I think I know who it is." We never broached the subject again. When another friend asked me ››

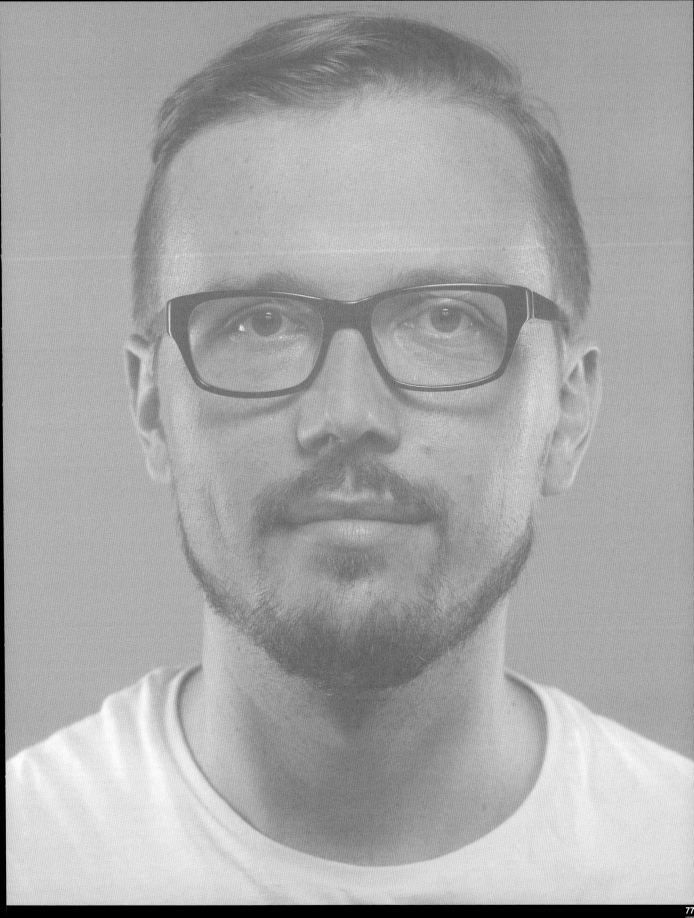

if I had a girlfriend, I said, "No, I have a boyfriend." "Oh, okay," was all she said. Then, our friends started pushing back on the way people used the word "gay" in front of us. At the time, if something was lame, it was "gay." Nobody talks like that anymore.

I lived with my boyfriend for quite a while. When he left for another city to study, things got screwed up.

Then came the Internet and online dating sites for gay men. I fell in love with Dawid on the first date. We can't break it off now, because our friends like him more than they like me. I joke that we are now doomed to be together.

I was raised in an emotionally cold environment. Keeping the house clean was more important that saying, "I love you, Mom." I am not close to my parents. I call once a week, and that's enough. When I visit them, Dad asks, "When am I going to have grandchildren?" The standard Christmas wish: children. My dad has a good sense of humor, but he is intimidated by my mom.

My parents must suspect something. They aren't stupid. My first boyfriend visited us once, Dawid maybe three times. The first time, my mom moved our beds apart. The second time, we slept in the same bed. I am scared that the atmosphere at home might turn sour, and I'm not sure I want that.

We don't hide it in our everyday life, but at home we are careful. My parents have been through enough already. They had five of us, and I tell myself that they have other priorities.

My siblings are a whole different story. I have two brothers and two sisters. One of my brothers refers to Dawid as his brother-in-law. He visits us, and we visit him. My older brother found it more difficult. He would say, "You are my brother, but it bothers me that gays hold hands in public. It's not normal." He's so Polish. He accepts me only because of his wife. We explained it to him. It took some time.

There are never any problems in new places or at a new job, but there are aspects of family life we can only dream about. Friends start getting married and buying houses, and we are stuck thinking, "It's time to find new friends." We can't get married, even though we want to, and we talk about it more and more. We can now ask for each other's medical information at hospitals because, thanks to Kampania Przeciwko Homofobii, the Ministry of Health recognizes same-sex couples. That said, a lot depends on the goodwill of the doctors. At work, Dawid is my emergency contact person, but so what? There are no legal means in Poland that would allow us to secure our future, even through a notarized act or through a will. We even have separate bank accounts. I don't know how to change all that.

I come from a small village near Kraków. My family has lived there for two generations. Half of them are coal miners. When I was two, my father died in the coal mine. My mom raised me alone until I was seven. Then, she married my step-father. At first, we didn't get on well because I was very jealous and possessive of my mom. We started to get along after my brother was born. I was sixteen then.

When I was in high school, I began to realize that I was somehow different, but I repressed it so much that I ended up joining some very conservative circles. I became religious, actively participated in the Light-Life Movement, and gave the impression that I was interested in girls. I knew I was lying to myself and others, but I cared about those relationships. I was very afraid back then, and deep down I felt unhappy. It later turned out that my fears were unjustified. I am still in touch with some of those people.

I moved to Kraków. I studied Polish philology. I met Adam during my first year of grad school. I had no experience with relationships. We decided that we would just have some fun, but

I fell in love with him right away. He kept his distance because he was caught between me and another relationship with a man, which he was about to end.

I loved him, and that made me stop pretending. I told two of my female friends. They didn't have any issues with it. I went home for the weekend. I was having a bad day. My mom was cooking, and she asked what had happened, why I was sad. I told her that things weren't shaping up. She wanted to know whether it was about a romantic relationship. I nodded. She asked if it was about a girl. I said no. Then, she asked, "But you're not gay, are you?" "I am, Mom." She tried to deny it: "You'll get over it." Later, she told me, "But don't tell Grandma and the neighbors." It was a blow. For the next couple of months we didn't talk about it at all, even though I went home every week. She told my step-dad. He said, "If you don't mind, then it's not going to bother me either." I think he has handled it much better than my mom.

My grandma found out from my mom while they were having some wine. She is very religious. She isn't thrilled. But we get along well without »

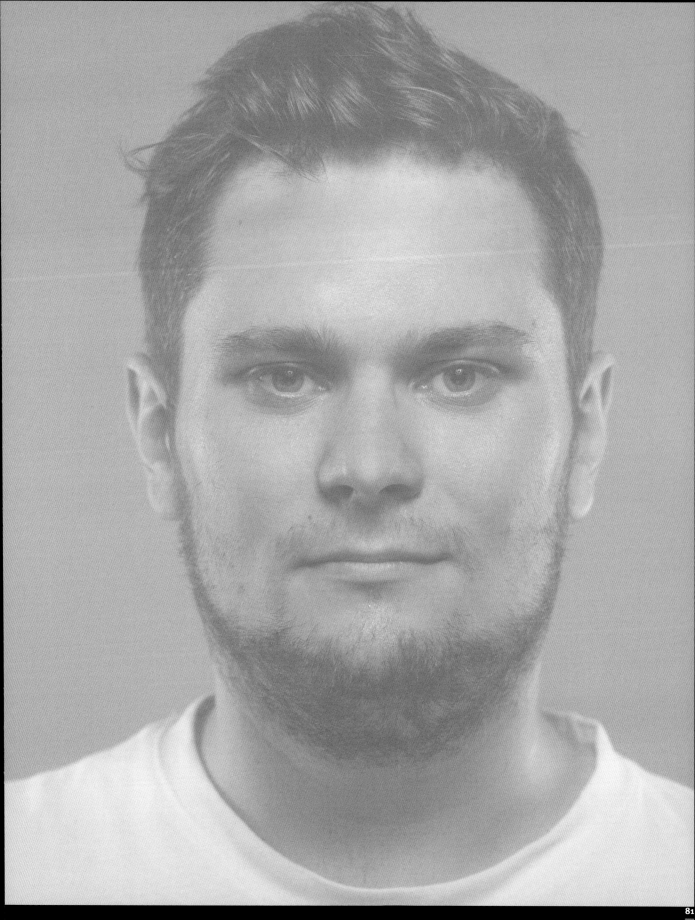

talking about it. My grandpa doesn't know. We aren't going to tell him, because, according to my mom, he gets very angry when he hears about gay people. I am not sad about it. I find it rather amusing. I brought Adam home and introduced him. We had ice cream with my brothers and parents. Now, we often visit my parents on the weekends. I don't hide being gay anymore. At school and at work, I say without blinking an eye that I have a boyfriend. I would feel bad if I didn't say it. I want it to be as normal as possible. I want it to be transparent.

Adam and I lived in London for a while. He liked his job because he had great colleagues, but I was unhappy in mine. I ended up in a warehouse, working only with men over fifty. We didn't have anything to talk about. Sometimes we chatted about TV shows. When our co-workers found out that we were a couple, they would point their fingers and laugh at us. It was the only sign of intolerance we have encountered. We felt bad. We filed a complaint with our supervisors. The jeers ended, but people still gave us strange looks. I really wanted to go back to Poland, partly because of the situation at work, partly because I missed my friends and family.

We are renting an apartment in Poland, but we are thinking of taking out a mortgage and buying our own place. Nobody wonders if we are a couple. We recently redecorated our apartment. Contractors came in, saw one bed, and didn't say anything. We are very lucky, or maybe we are living in a bubble? Looking at the results of the elections and the majority who voted, I keep wondering who these people are, because I don't know them. Sometimes I get the impression that we provoke aggressive behavior. When we see somebody collecting signatures under a petition to ban abortion, we ridicule them, we openly show our disapproval. Even though we hear about the beatings, we behave rather carelessly because homophobia has never affected us very much. During the parades, the police protect us.

Last weekend, we took my brothers to a work picnic on Children's Day. They are nine and five. Their behavior was exemplary. We went to a park with a dirty pond and rented water bikes. The younger one was so excited that he was pedaling like crazy. It felt good to be with them. I took a video of them eating cookies. The older one remembered seeing us lying in bed in our parents' house, and he said, "You cuddled so sweetly."

I am forty-eight. I come from Tri-City, where in the nineties the only place for gay people to meet was a hidden barracks, which even I didn't know about. A few decades have passed since then, and I'm convinced that, even though non-heteronormative people now have their own spaces to meet, play, and socialize, they still face enormous challenges. When I was discovering my own identity, I didn't have my own space. I asked a friend in grad school if he knew any lesbians. He was taken aback by my question. He was gay, and gay men in Poland do not hang out with lesbians; this is how it was in the past, and this is how it is now. In the late nineties, when there was no Internet, you had to go to the "girl seeks girl" section of the personal ads in a newspaper. At the time, I wasn't looking for girls. I wasn't looking for boys either. This wasn't only because of my fear of the Church or of being ostracized by the society—I was already a non-believer by then. In my case, it was mainly because of family, because of family dependencies and unresolved childhood hurt and trauma. The icing on the cake was my sexual orientation.

To live in agreement with yourself is a big decision. For a long time, I wouldn't come out even to myself. I wouldn't name what I felt. I was in a state of ongoing conflict with myself. I drank a lot, which is common in our community even now. In those days, finding psychological help wasn't easy. There were a few private psychotherapy offices, but I was a poor student. I went to the church psychologist because she gave free consultations. She told me a story about two lesbians who had quarreled over a baby and how one had stabbed the other to death. She asked me if I knew what I was getting myself into. She succeeded in making me even more repressed for the next couple of years. Loneliness and alienation are horrible. I was afraid to look at women, let alone at men!

Once I had a job, I went to therapy for six years, and I started to define myself anew. I rebuilt my self-esteem and found answers to who I was and who I wanted to be. To become familiar with my sexual orientation I would stand in front of the mirror and say the word "lesbian." At first I thought my lips would fall off!

Sexual orientation is not a matter of who you'll go to bed with. For me, it is about emotional engagement, about getting close enough to another person that you feel safe with them. "Safety" and "trust" are key words here. »

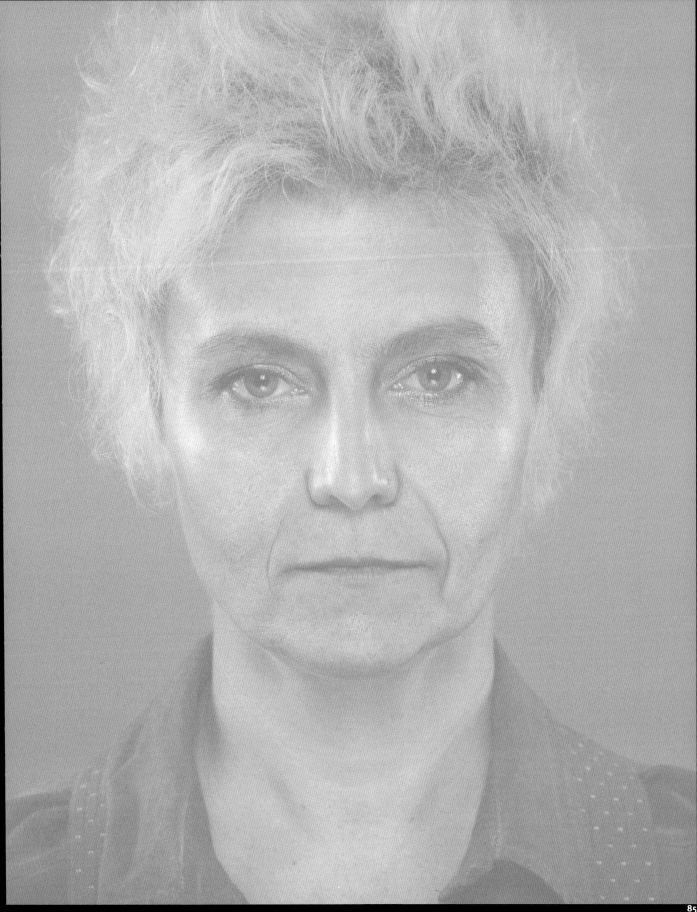

already knew. "Then why didn't you tell me?" I asked. "Why did I drink liters and liters of alcohol because I was unhappy and conflicted?" I came out to my family when I was forty-two. It made me feel good. It's a big problem for them, but I know now how to fight for myself. If they really consider themselves family and claim they love me, they have an obligation to accept me. And if they have doubts, I should accept that it's difficult for them. It works both ways, but unfortunately they haven't tried to understand me.

I had put my art on hold for ten years to have a professional career and make some money. I had shut myself off from the world. I couldn't talk about it. It was just me and my pain. But after coming out, I opened up to myself and my creative desires. Five years ago, I moved from Tri-City to Warsaw, and I took out a loan and bought an apartment so that I could have my own space. I separated myself from my family. I now had the freedom to act. I met great, creative people.

Right now I'm primarily a comic book artist. I'd like to bring together a group of female comic artists who would support and collaborate with one another, a community of "drawing girls." It's said or "women's arts," because there is only good art and bad art. But everyone knows that "good" here is what men do, and "bad" is what women do. The patriarchy has left its mark on women's thinking, and also on their self-esteem in the arts and comic-book worlds. For that reason, the very act of emphasizing one's gender in a work of art becomes a political act, not only a creative one. In spite of these obstacles, I believe that Poland will belong to women. As a continuously marginalized and stereotyped community that includes non-heteronormative women, we will seek a new definition of the world and our own place in it. Polish women are no longer afraid of taking risks.

For me, what's most important is that no one takes away my voice. I can deal with everything else. We must refer to women's art as women's art. It's important to name it. What isn't named doesn't exist in our consciousness, and by extension the public space. I am ready to face reality as Beata Sosnowska—artist, lesbian. As a lesbian artist I draw drawings with lesbian themes, and I want to harness my talent in support of LGBTQ rights. This is my mission. So what if I am "that dyke"? Art remains art. My art is my truth.

Artur Maciejewski

I'm twenty-three years old, and I've been living in Kraków for five years. I came here to study physics at Jagiellonian University, where both of my parents are faculty members.

I came out to my parents when I was fifteen. Their reaction was: "Ah, okay." They didn't show any emotion. In hindsight, I think that what I did was stupid. Nobody should make a decision like that when it's unclear what will happen. It was dangerous because we live in a country that doesn't accept LGBTQ people, and there is a chance that a young person who comes out might be thrown out of their home. There is a reason why LGBTQ people are overrepresented among homeless young people. Even in liberal Western countries, like Canada or the United States, sexual orientation and identity are the reason why many teenagers are thrown out of their homes. I acted impulsively. I didn't know what to expect.

In high school in Gliwice, I came out only to some of my friends. Teenagers aren't the nicest people, and any kind of difference can become a reason to destroy another person. There was someone at school who was gay, came out, and his life was over after that. He even didn't have to come out; the rumors had been enough.

I don't think my sexual orientation is anyone else's concern. I don't see any reason why I should talk about my private life at all. But I did decide to check the sexual orientation box on Facebook, and then some people stopped saying hi to me. There were unpleasant reactions from friends in my hometown, but I'd already lost touch with them, so their opinions didn't matter.

I don't want my boyfriend to go to Gliwice with me to visit my parents. Not because they haven't accepted my choices, but because I just don't like going to visit them very much. It's not related to my sexual orientation. They simply aren't nice people. They want to know everything about me, which is exhausting. They call it "care"; I call it "need for control." I prefer not to have too much contact with them. Sometimes, I call them out of duty. That said, two years ago, my mom saw me on TV in the pride parade. She called me and said she was proud of me. »

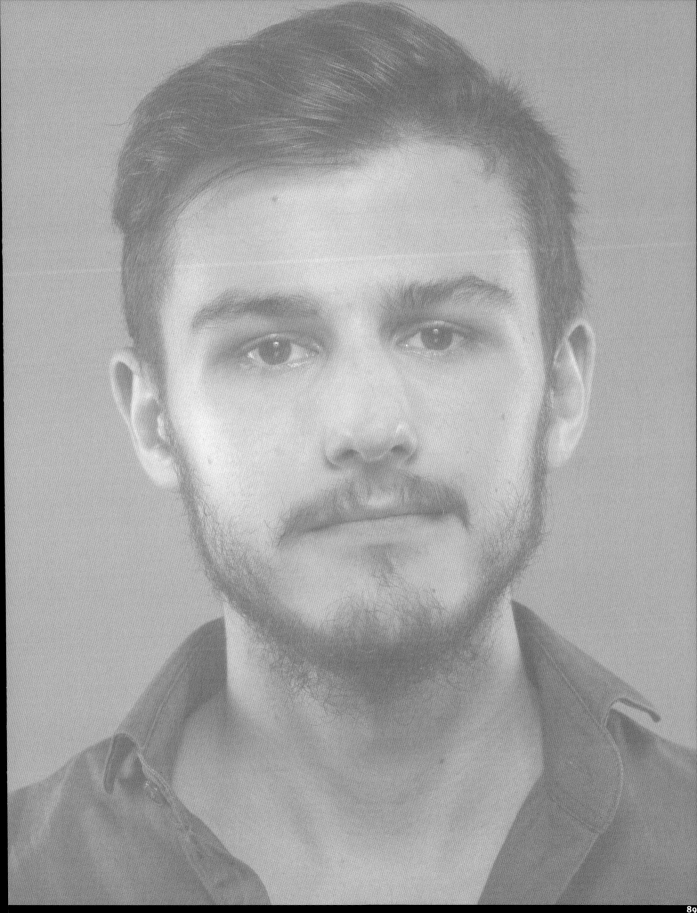

I am an LGBTQ activist. I organize pride parades. I'm involved in activism against discrimination. I don't have a personal stake in the rights we are fighting for. I'm not personally interested in same-sex adoption, because I don't want to have children. I don't personally care about civil unions and same-sex marriage, because I don't want to get married. But we don't always need to have a personal stake in the fight in order to advocate for a given right. There's something else that motivates me—equality. No one should be denied rights only because they're different, because they have characteristics that others don't like. What's most important is to have opportunities.

I'd like to leave Poland, not because it's a country hostile toward LGBTQ people, but because it's a country hostile toward people in general. Living here is difficult. Our country doesn't support its citizens. The need to control human behavior is all-pervasive. It's stuffy. It's hard to be who you want to be.

There is a problem in Poland that accounts for why the LGBTQ movement has had so few successes.

The truth is that there is no LGBTQ community in our country, no commonality, no solidarity. I think that people simply don't appreciate that together you can achieve much more than if you act alone. I'm irritated that some people are so walled off and feel so secure that they think that being gay or lesbian in Poland is not an issue. Of course it's not an issue if you're making 20,000 zloty a month and living on the thirtieth floor of a high-rise. In smaller towns, it's impossible.

It's not true that coming out solves every problem. We can't demand that everyone come out of the closet. Some people don't have a choice, because if they come out they'll be beaten up, thrown out of their home, or will run away. A person should come out only if nothing bad will happen to them, if what prevents them are only their irrational fears. But we can't pretend that everyone welcomes our presence. When we try to report a homophobic or transphobic crime, the police say that there is no legal clause to recognize crimes motivated by hatred of LGBTQ people.

Miko Czerwiński

I went to a Catholic high school. Each week or month—depending on how long the fun would last—my classmates would select a minority group to poke fun at. There was a week of poking fun at gays, Jews, Native Americans. I found it exasperating. I felt personally affected by it, though I couldn't yet say why.

I came out to my parents after I graduated from high school. I remember how nervous I was. It was a weekend morning. My parents were still in bed. I stood in the door to their bedroom and said, "I think I'm gay," and started crying. They were totally shocked. There was complete silence for about five minutes. After that they were fine. They asked a lot of questions, but I never heard anything like "Why did you do this to us?" even though I'm an only child.

After high school, I went to study in London. I felt good living there, free; I could come out. I found a lot of strength in the fact that people accepted LGBTQ people. But then I had to go back to Poland. After I returned, I came out to my other friends, the more conservative ones, and decided that I would finish grad school in Kraków. I needed to meet other LGBTQ people and support their causes. I started working for NGOs that focused on preventing discrimination and human rights abuses. I co-organize the pride march in Kraków.

I was afraid to come out in grad school. I don't remember when my boyfriend Artur and I started to talk openly about our sexual orientation on Facebook. Earlier, I would hide some of my posts from new friends while I was still feeling them out. Finally, I decided that to be an activist I couldn't go on hiding it, and I made my profile public to everyone. None of my Facebook friends had an issue with it, but some things got complicated. I'd forgotten that my distant relatives are on there, and my cousin showed my post to my aunts. They said that they don't understand and won't accept it, but that they won't interfere. The message was »

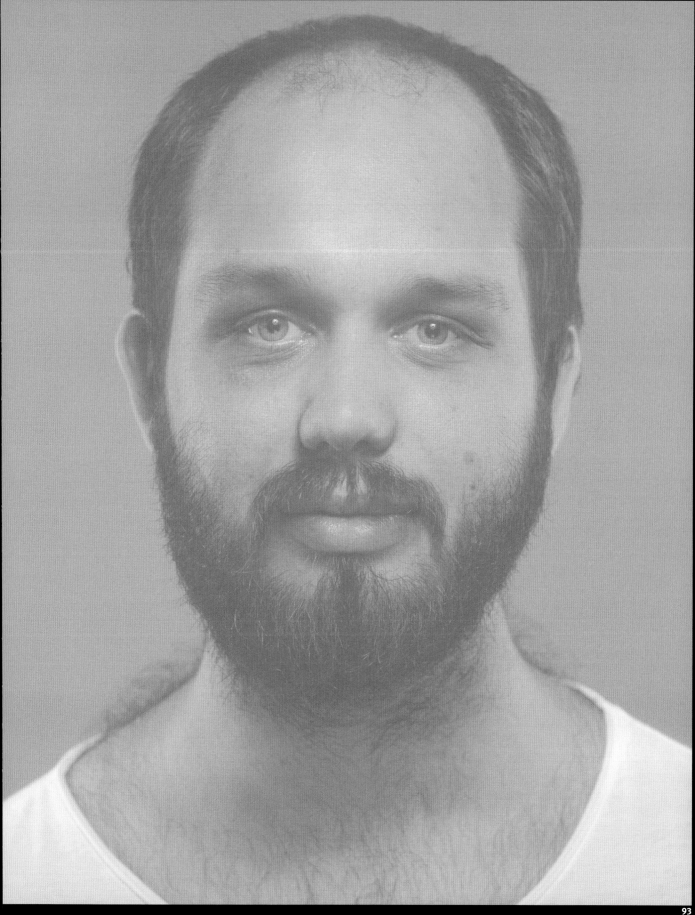

this." "Just don't let your grandpa know." "He's a fanatic Catholic. He watches TV Trwam.[6] I don't think he knows. I see him once every two or three years. He cares about other things. My cousin, the only atheist in the family, called me once and said that he was happy there was someone among us who was normal, who wasn't crazy about religion. He congratulated me on the fact that I was living my own life.

I was surprised when a friend from grad school, a nationalist who had no issue accepting me as gay, expressed homophobic and anti-Semitic views during a Jewish festival. His attitude was negative, but not toward me. Things can get unpleasant, though. One of our neighbors has nationalists among his friends. During their parties, they sing homophobic songs under our window. We have never called the police. They meet at night, so you can't quite see who they are. We're thinking of moving, but apartments in Kraków are expensive.

Artur and I have been together for four years. At first, we had no problems hugging or holding hands in public. Two years ago we experienced a series of attacks. We were called "faggots." People made comments about our sexual orientation. Some boys tried to impress girls with their homophobic behavior and comments. The worst thing happened in Kazimierz, Kraków's gay-Jewish district, as it's jokingly called. We were approached by a drunk who started yelling, "Faggots, the police are going to pick you up." We could see he wanted to take a swing at us. We started to move away. We had to get on a random tram to escape him. Ever since then, we have been afraid of kissing or holding hands in public. I need to feel comfortable and safe in order to be able to do that. In Kraków, the pride march is one place where we feel safe. I feel fully myself there, but otherwise we can only express our feelings in public in Warsaw or abroad.

[6] TV channel dedicated to Catholic programming.

So much has happened in my life.

I looked completely different when I was twenty: forty-four pounds lighter, shoulder-length hair, cleavage, high-heeled shoes—a lady. I worked in a theater. I had dreamed of being a director, but in those days, in mainstream theater, there were hardly any female directors. I was an actress, and the way I looked both gave me opportunities and stopped me from getting certain roles. The sexual perception of who I was made me angry—and I was angry that so little was up to me.

At some point, I put on army boots, cut my hair short, put on weight, and became the person you see today. It made me feel like I was an artist, regardless of how absurd that might seem.

I came out to myself while looking into a bathroom mirror. My mom realized I was a lesbian when my first girlfriend brought me a bouquet of twenty-five roses. The next day, we had a row. My mom was shouting that lesbians were women who had been to prison and that people would point their fingers at me. It took a while before I was accepted at home.

My first partner, Ania, and I founded the lesbian arts group WAGINA—Warsaw's Active Group of Artistic Initiatives. We would paint, record audio plays, take photographs. We would perform. My second partner, also Ania, and I started a band. We had a few rehearsals in the basement of a swimming pool complex. We'd mastered one song by the time the band broke up.

In those days I was a "patriarchal lesbian." Dinners. Shopping. A middle-class life. Luckily, that period is over thanks to Agnieszka. We have been together since 2009, and for eight years we have also been *Female Creative Tandem*. We both graduated from the Academy of Dramatic Art, and we have the same values—courage, passion, reflection.

We started with what we know best—theater. Our first performance was a stage adaptation of Virginia Woolf's *Orlando*. It was a crazy idea. We had no funding. We operate as an informal group. We had no established network or venue, but it turned out that a female group could be put together fairly quickly, and the difficult conditions toughened us up. We held our »

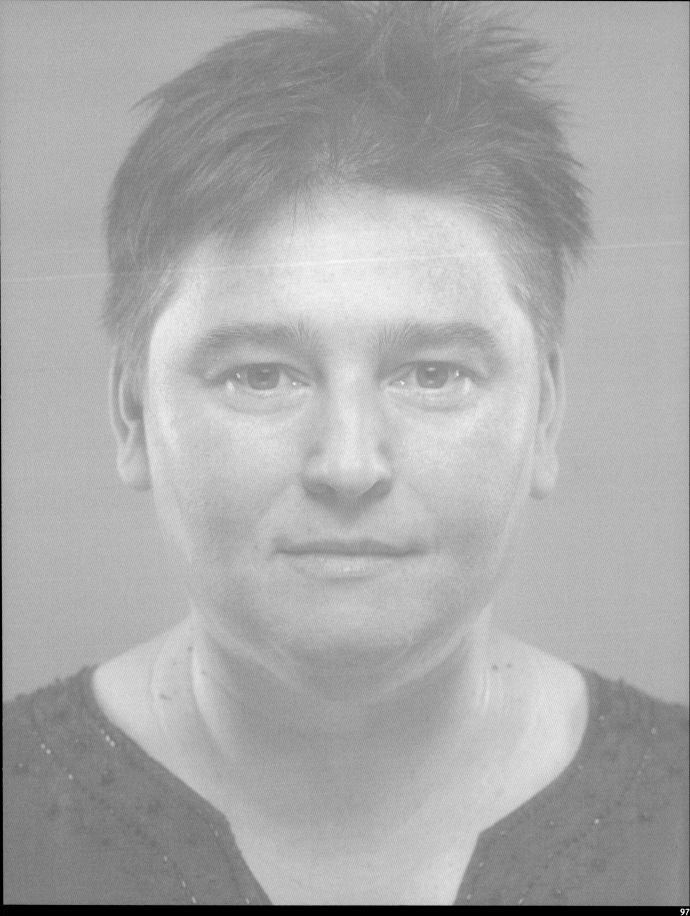

rehearsals at UFA [7] headquarters in Warsaw—in the basement, on the concrete floor. It was a pretty cold winter. We could see our own breath, and the dust would rise from the floor. We had to pour cold water over the floor so we could breathe. The premiere took place in July. It was a beautiful performance and a unique experience— nine women of different sexual orientations and personalities, most of us without much theater training. Agnieszka directed it. It was her world.

The next performance reflected my world. *33 Sztuka* was written by me, and it was a very intimate text about a lesbian polyamorous experience. We invited two actresses from the previous project, and I played one of the roles. Fortunately, my role's protagonist was background to the action. I learned a lot thanks to Ania and Iwona, and of course thanks to Agnieszka.

But theater is not everything. We felt compelled to do something bigger, something that would finally give us an opportunity to examine lesbian culture in Poland. And so we organized a lesbian festival called Lesbian Culture Space O'LESS. In 2012, we brought together all the female artists who in one way or another identified as lesbian. We organized an art show, spiritual events, dramatic readings, and a music show.

At the 2013 festival we focused more on spirituality, reflecting on whether something like lesbian spirituality existed, and in 2014 the festival was dedicated to film. In addition to screening lesbian, mostly Polish, cinema, we decided to make films. We produced three short films in twenty-four hours. That festival gave me the energy to do a big film project—a documentary about contemporary Polish lesbian poets, *L.POETS*. It premiered in November 2016. Now, we're working on a play about Gertrude Stein and Alice B. Toklas.

We're fighting for our art to be respected. We have a lot to offer, but I often have the impression that we're operating in a vacuum. At the same time, we can't stop creating, because we are artists and we need to express ourselves. I have no intention of pretending that being a lesbian is something private. Lesbian identity has shaped me. I wonder what kind of an artist I would be if I were straight, and all I see is an empty career.

[7] UFA is a female queer sociocultural center run by a collective of volunteers.

I was a good girl until I started attending gender studies classes in Warsaw. It was an awakening, a new perspective on how to live in a patriarchal world, knowing that it's not a place for women.

I was living in a family where no one had ever spoken the word "lesbian," but I had dreams about intimate relationships with women. In the real world, I'd always had deep relationships with women—men were afraid of me.

Then, I met Monika, and this was the beginning of the *Female Creative Tandem*. We had both graduated from Warsaw's National Academy of Dramatic Arts and were united by our love of theater and an uncontrollable urge to giggle. I felt like I was in paradise, that everything was possible because I had escaped heteronormativity, that now as a lesbian-feminist-artist I had a bright future. I was so wrong.

Contrary to my expectations, I found myself in a world where nothing much separated "gay life" from "normal life," whereas I think that a non-heteronormative identity should be an opportunity to break free from that "normal life," which is so overtly codified, boring, and schematic. For me, the fight is for more than simply accepting that you can love someone of the same sex and that you don't have to adhere to the gender binary.

I don't fit into the mainstream, and I don't want to become part of it. I escaped it so that I didn't have to conform and assimilate. The inclination to assimilate certainly prevails in the LGBTQ community in Poland.

I have no intention of sneaking around, of pretending that being a lesbian is my private affair and that it's only about my erotic life. For me, it's an identity. I think that my courageous rebel foremothers made it possible for me to be a feminist and lesbian who is free, and I want to convey this through art. For that reason, the culture of non-heteronormative women is something that's especially important to me.

With Monika, I'm trying to help create a non-heteronormative alternative culture. Unfortunately, to do that you have to find a ››

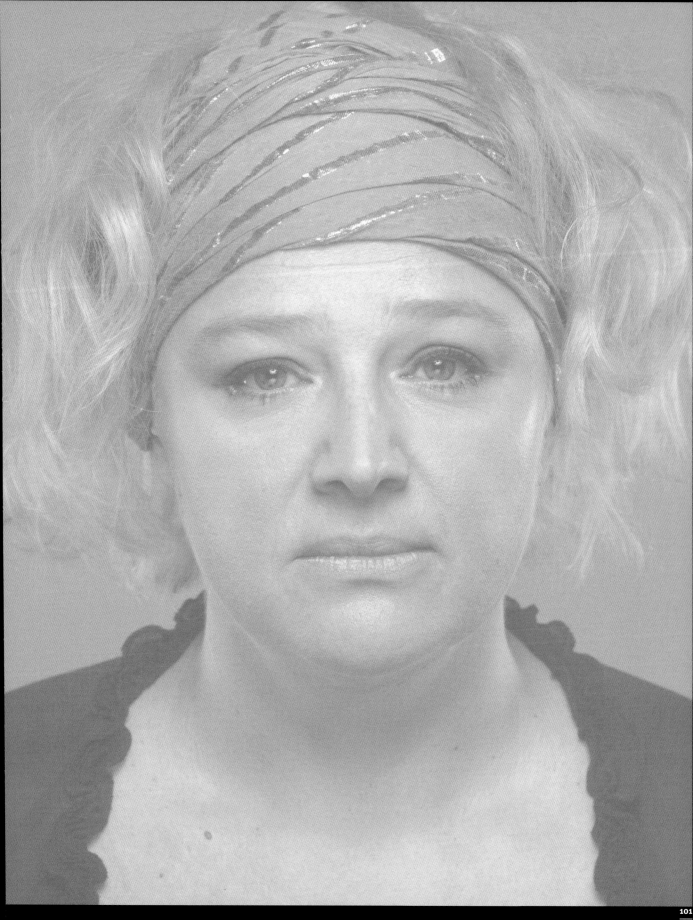

space to exhibit your art. Then, you have to encourage the audience to want to see something that hasn't been undersigned by an official institution or famous artist. Monika and I try to illuminate the work of the artists who use their art to talk about their identity. We believe that art is an alternative way of talking about who you are, a different way of communicating than social activism and placard slogans. And we think it's an especially important means of communication for non-heteronormative women. Most of us operate outside the mainstream, in feminist groups that try to be democratic and that seek a way to create an alternative to the authoritarian, hierarchical order. But these groups are rare.

Most lesbians stay at home, blending into their lives of cats and mortgages. Those who are well-off typically think that there's no discrimination—they work in tolerant international corporations and travel all over the world. They don't need change. Many of them don't feel the need to be actively open about their sexuality, while the lesbians who work in the LGBTQ world in Poland are either submissive peons or strong feminists who are seen as aggressive and difficult to work with. This effectively means the real beneficiaries of change when it comes to LGBTQ rights in Poland are the more visible gay men. That hurts.

We're going to continue doing what we do. We won't give up. We have the Internet, which is a mine of knowledge and a valuable archive—you can put anything online. We have the basic technology allowing us to produce films or record podcasts. A cell phone or iPhone is all you need these days. At the moment, there's still too little lesbian cultural production, but we believe that will change. Sometimes, it's simply a lack of money; sometimes, there's not enough energy. We hope that what we've started will not be lost. Feminists fought for what is rightfully theirs for dozens of years until they succeeded—nothing happens immediately. There are many ways to bring about change.

I am a man living in a woman's body, and I bear a grudge against the Catholic Church. Its teachings continue to destroy the lives of LGBTQ people. The catechism describes being LGBTQ as a sin, a handicap. It says that LGBTQ people are worse than heterosexual human beings. That, to me, is unacceptable. I am a father of three, a pediatrician, and I know how damaging this message can be to one's upbringing. It's unbelievable that even now the Church can use language like this, talking about the higher-than-average propensity for sin among the LGBTQ community. It feeds the hatred of parishioners, which spreads to people outside the Church.

I am a believer. I believe that Jesus spoke the truth, and I have no reason to believe he lied when he called himself the son of God and when he called God love. For me, he is a heroic figure, a pacifist defending people and accepting persecution and death with the utmost dignity.

This is what I think is the core of Christianity—not what the Church has invented throughout the ages. It's no secret that the Church has persecuted scientists, maintained that no one outside of the Church can be saved, and refused proper burial to those who committed suicide. I think it's high time change came from within the Church.

I belong to the Catholic Church. I was baptized. I attend Sunday Mass every week. I don't see why I should be removed from the fellowship of the church. I could decide to join another, more open Christian church, but why would I? I don't get it. Instead, I feel I have a duty to do something for, to fix, my Catholic community. Wiara i Tęcza (Faith and the Rainbow) was founded to let everyone—but above all, all those humiliated and demeaned lesbians, gays, transgender, and bisexual people—know that they are beautiful and good, that they can have a wonderful life, that if their relationships are based on love then they are »

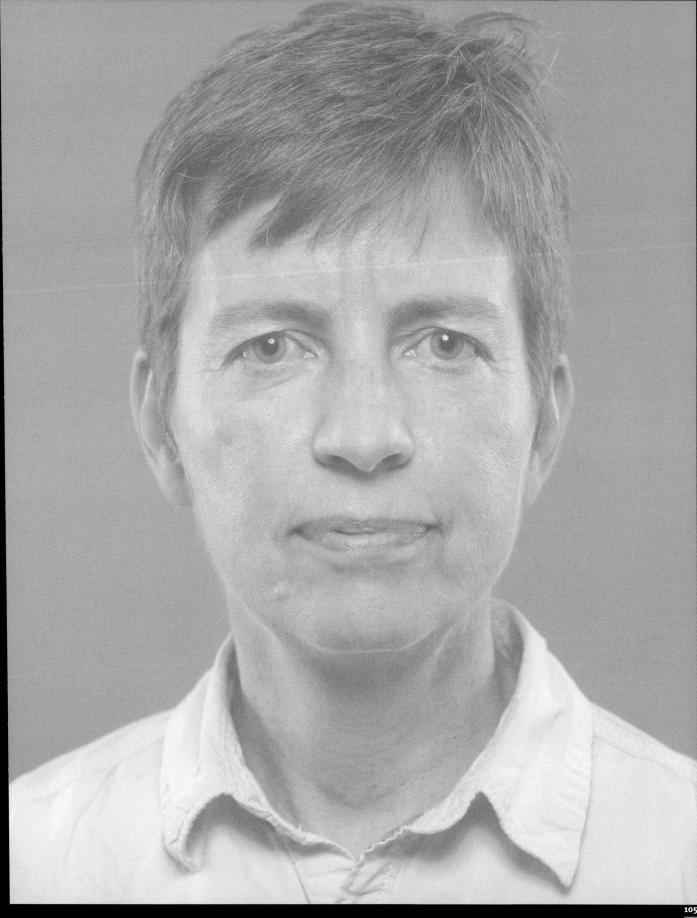

beautiful and valuable to their own lives and to the whole society. This should be considered the good of the Church. Wiara i Tęcza was established in order to appreciate people, to lift them up, to invite them into the Church if they still want to be part of it. We want to support one another's growth and provide companionship. To those who were raised to be afraid of us and who think that we are monsters, we want to show that we are human beings, we want them to get to know us, we want to persuade them to change their mind.

Wiara i Tęcza was created on November 7, 2010, and we have been meeting ever since. We don't register our members. People can engage with us by reading our posts and articles and finding comfort in being able to identify with us. People can also attend our spiritual retreats and meetings, and those who want to do something can act. We have a few hundred activists as part of our organization.

There are commendable exceptions among the Polish clergy who want to help us. We know about a dozen of them, and we really appreciate their work. We can refer to them the gay, lesbian, transgender, and bisexual people who have been physically and psychologically abused and who are in need of pastoral care. We also have friendly Lutheran and Anglican priests in our network, and priests from two churches—the Reformed Catholic Church and the United Ecumenical Catholic Church—who are openly welcoming of LGBTQ people and bless LGBTQ relationships.

I am openly out, although in some social situations I don't mind it when someone calls me Barbara. Barbara is part of my life, too, but psychologically I am Artur. I'm sure there are more people like me, and I believe that they will feel reassured when they hear this because they will know that they are not alone in the world.

Being as old as I am, I know that it's very difficult to live in Poland and be different. Mom, dad, and two kids is still the standard social unit. Anyone who doesn't fit that model faces difficulties, especially if they're in the lower economic classes. Among the various issues we all have to deal with, the problems of LGBTQ people aren't treated seriously, if at all, but we must have the right to live as citizens of this country. Politics won't change anything. All you end up with there is promises. Everyone in politics is conservative, and when someone who is on our side does come along, they're silenced and ridiculed. Ridiculing our community is still a popular thing to do.

In the fifties and sixties, if you weren't straight, then your sexuality was completely shrouded in silence. People would say with disgust, "That's some faggot" or "That's some dyke." They meant to offend. This is how my mother would use those words. When my parents noticed that I was different from other girls, they started watching me with concern. My mom would accuse me of always being surrounded only by women. "When are you going to start thinking about the future and look for a life partner?" she would ask. I never had the courage to look her in the eye and say, "You're not going to see that happen, Mom." I knew this would hurt her, so I saved the truth for later.

But I gave off signals. She must have seen them, suspected something, spoken with my brothers. After my father died, when I was in my forties, we were driving, and my mom asked: "Tell me, Romeczka, is it true that you are a lesbian? Dad always thought so, but I never believed him." I said, "Yes, it's true," and I saw the hurt and disappointment on her face. She sighed, "So, your father was right. What a pity that your life turned out this way." I can't make a seventy-year-old person change her beliefs.

For me, my difference has been a source of fascination. I was excited about what I noticed about myself during my adolescence. I thought that maybe something would be different about my life, more interesting. Being sexually attracted »

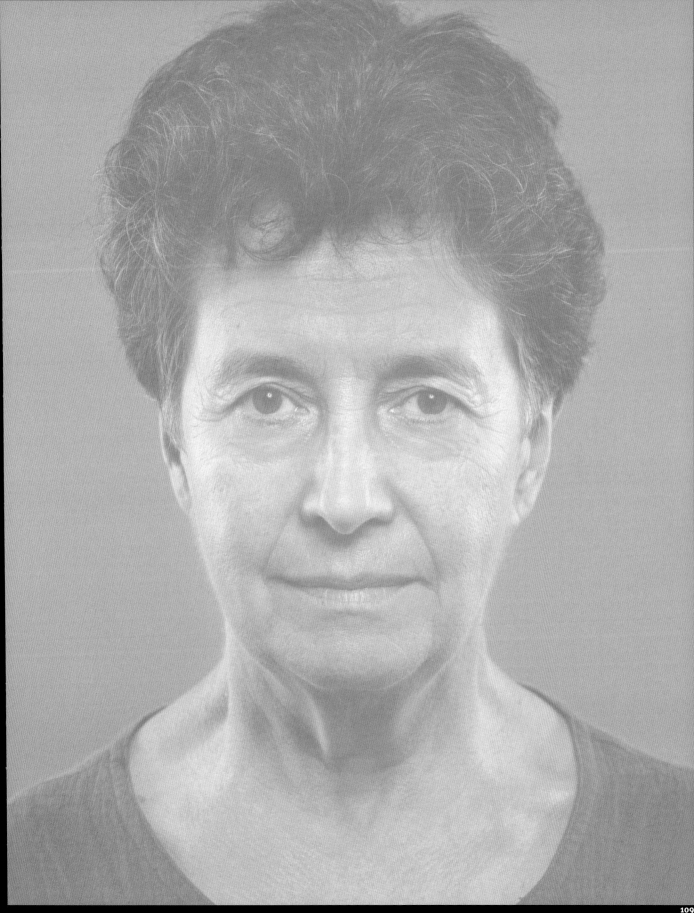

to my female friends was exciting to me. Deep down, I think I am bisexual.

I was an activist in the nineties. I was particularly motivated to do something for lesbians because I was in a relationship—a very good connection, a new friendship. We felt stronger thinking that we could be together, and we started to think about what we could do to help other women be together. We started to organize meetings. The first was Lambda in Kraków. We received a lot of letters. Young women shared their experiences and sought support by mailing letters to a special P.O. box. But we noticed that once people paired up, once they got into a relationship, three quarters of the energy to organize for the LGBTQ community fizzled out.

A few very engaged activists emerged at the beginning of the nineties. In Kraków, there was Jerzy Krzyszpień, the founder and leader of Kraków's Lambda. In 2013, he created the website *Wychodzimy z ukrycia* (We're Coming Out). He is an incredible man, very wise, because he knows that

coming out, talking about oneself, and opening oneself up are critical. He has a degree in English philology, so all the posts on his site are also in English.

The fact that I can look at things from an LGBTQ person's perspective, even though many of my friends don't see me as a lesbian, makes it possible for me to view many things differently, more deeply, and not in stereotypes, unlike, for example, my brothers, who are fathers and husbands. They don't know how to talk with me about how I am different. There is a wall between them and me, raised not out of resentment but out of an inability to talk about this subject. They don't dare to ask about even the crude basics. Maybe they find it so awkward that they'd rather talk about trivial things, like the weather or about how their kids are doing, or about work—not about what's going on in my own life. They've never asked me how I'm doing. I am their sister. They could make the effort to find out something about me. I know a lot about them. I take an interest in their children, their wives, the

day-to-day things. I call them to ask how they are. They'll tell me. It might not be deep, but it's still meaningful. But they don't ask about me, so I don't feel comfortable talking about myself. It's hurtful, but I blot it out and try to maintain a cordial, loving relationship with them. They're my brothers, after all. I miss having a real conversation with them because they're close to me. It's a pity.

I get on best with other LGBTQ people. One of my gay friends, a German who now permanently lives in Poland, once said, "My country, my community, is neither Poland, nor Warsaw, nor Germany, nor Europe. It's the international LGBTQ community because with them I can be myself." I feel the same. That's why I attend Wiara i Tęcza's meetings. We've found common ground there through sharing so much. We know the most elementary things about each other, so we feel close by default, without having to define it. I don't like the phrase "reveal one's identity." It's not about revealing. It's about not hiding anything. Speak where you have to. Don't skirt around the issue. It's a learning process for us too because we have been raised in a homophobic society and we have internalized this homophobia. I myself find certain things difficult to articulate because I come from a Catholic, conservative Polish family where we have never spoken about living life to the fullest.

LGBTQ people should be able to fulfill their potential in society as complete human beings. Straight people can show their heterosexuality in a natural way from the day they are born. In preschool, for example, if a boy wants to dance with a girl, or a girl with a boy, he or she can. But a twelve-year-old boy or girl cannot ask a person of the same sex to dance with them at a school dance. A young man is not going to display a photo of his boyfriend on his desk at work, while his straight co-workers are surrounded with photographs of their loved ones—family, fiancées, bridegrooms. It's everyday discrimination. You can't do something, because you're afraid of what others are going to say about you. This causes only negative thoughts about yourself. »

It's an inexhaustible subject, but it releases in you a need to speak, to share. I am single; I don't have people I'm very close to. If I meet someone, it's socially. I say a few things about myself, but I don't launch into a monologue, because people would think I'm an exhibitionist. When I was young and exploring my sexual preferences, I couldn't talk to anyone about it. I could only learn how not to talk about myself, meaning how to hide a big part of my personality, my identity. It was awful. It does so much harm to a young person, so much irreparable damage to how you think about yourself and perceive yourself in relation to other people. Maybe confident individuals deal with this better. I don't know. I suspect everyone finds it difficult. It's certainly been easier for me since 2000, but it hasn't been the same for everyone.

There are self-confident people, and there are people who are shy, who have low self-esteem, who find it as difficult as I did in the seventies. You hear about young people who can't cope with the process of self-discovery committing suicide. I sympathize with them.

I can't go back and change my life. I know I've squandered a lot of opportunities. If I had lived my life out in the open, formed relationships with people of the same sex without thinking that it was going to be more difficult, I could have been more fully myself. I could have realized my full potential. But I missed out because the energy it took to keep my place in society, to hide how I was different, didn't leave much energy for other things. It didn't let me realize my professional, intellectual, or social potential. It's so important for a young person to form a circle of close friends and be a friend to other people. I was shy, withdrawn; I didn't cope well among people, and so I had fewer chances to form friendships and— what I desired even more—relationships. I've had three relationships with women, none of them very successful. I live alone. Now, I don't even dream about having a relationship. You have to let others get to know you, like you, become your friends. I didn't know how to do that. I'm frustrated now when I think about it. I could have lived my life much better.

I've always felt I was different. My father came from Angola, my mother from St. Thomas. They met in Łódź while studying Polish philology. I haven't had any contact with my father since I was two. I don't know how he's doing. My life has been difficult, but I can't blame my mother for not finding a better job, for not having enough money, for not sticking up for me. I don't feel Polish. I don't care about Polish citizenship. I don't feel wanted here. Maybe it would be easier in a different country, where I wouldn't be such a minority.

As a black kid, I dreamed of being a blond white boy with blue eyes. I wanted people to like me. I wanted to be like everyone else. I didn't want to stick out. We moved around a lot. I changed schools often, and had to adjust to a new environment each time. It was more difficult for me than it would have been for a white person. I'll always be vulnerable because of the color of my skin. In the past, every time I went out I heard comments. I was timid, but I always responded when people called me names. I didn't let others push me or spit on me. People would back off because they saw I would fight.

I don't react like this anymore. I am calmer, more optimistic. I'd like to help everyone. Even when someone attacks me, I feel sorry for the person. Those people need help. I understand why Poles are frustrated. I know why they can be so aggressive. I work here, and I know that it's difficult to survive from paycheck to paycheck. Frustrated people take it out on others. In the United States, a desperate man would likely pull out a gun. It's probably better here—people's reactions are limited to shoving and pushing.

I realized that I didn't identify with my body at puberty. I was eleven when I faced my mom and older brother and told them that I would transition. I had no idea how to do it, but I felt I had to. My mom didn't believe me. She started laughing and told me to stop talking nonsense. My brother, five years older than me, supported me. When he learned that I wanted to transition, he understood why he hadn't been able to get along with me: he had a younger sister who acted like a boy. As a girl, I always had a crush on my girlfriends. I would hang out with other boys. Together with other boys, I looked under girls' skirts. I said that I was a boy whenever anyone tried to accuse me of acting like a girl. I said I wanted to have a girlfriend.

My brother and I didn't have to debate it. He simply started treating me like his brother. He would even lend me his clothes. Sadly, he's no longer alive. »

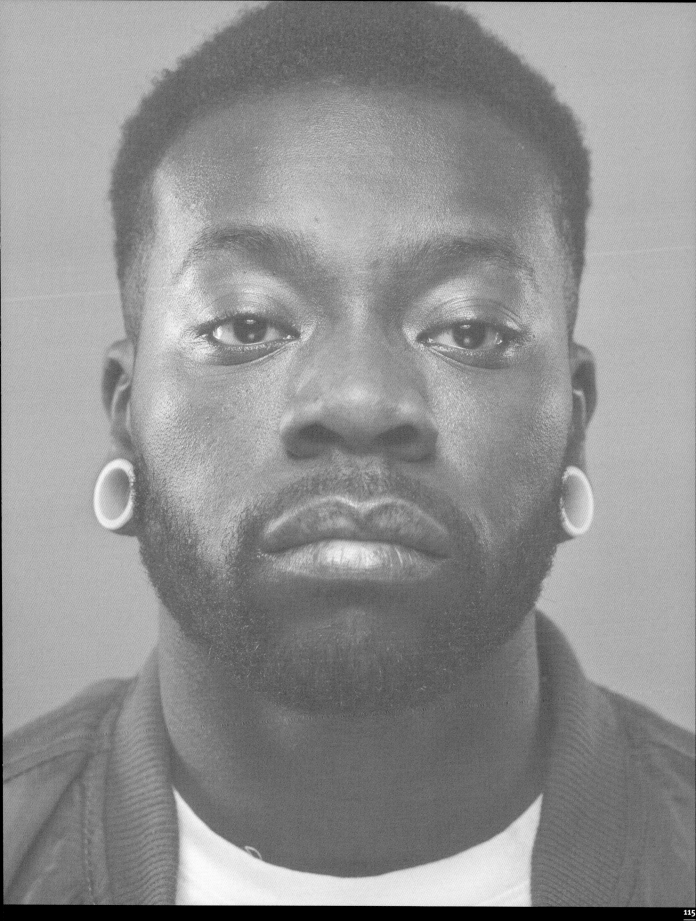

My mom didn't broach the subject. When she finds something uncomfortable, she doesn't talk about it until she has to. But I was open, direct, and confident about the decision I'd made. When I completed the tests to start taking testosterone, she understood that it wasn't a whim. She told me she wanted me to be happy. If I was happy, then she would be happy, too. I've been transitioning in Poland. I started in 2012, and I'm now at the penultimate stage. I'm not sure if I'll go through with it. I feel good now. I look in the mirror and see Chris.

First, I had to accept myself and my body. I was slim, curvy from the waist down. I've always had muscular arms because I danced for many years. Before transitioning, I didn't feel the need to have a masculine body, but growing a beard was the most important thing for me. Many people consider a beard to be the first sign of masculinity. All my life I wanted to have a beard. My body wasn't a priority.

I've changed most in the last two years. I've realized I'm bisexual. I fell in love for the first time at the end of the middle school, and she was a girl. My last girlfriend was bisexual, too. We met when we were twenty-two. We were together for four years. I've been single for a year and a half. I haven't met anyone I'd like to be with. I go to gay clubs and go on online social networking and dating sites. As a transgender person, I feel that people are most interested in what it means to sleep with someone like me and not what it would be like to get to know me. I am used to being called a "nigger" but not a "faggot." My transition is invisible from the outside. It doesn't provoke negative reactions. It's only a problem in relationships.

I am slowly becoming someone people recognize. I give interviews to support LGBTQ causes. I make YouTube videos in which I talk about my transition. There's a documentary currently being made about me. I've received a lot of congratulatory messages. People say that I am brave, but I don't feel like I'm entirely out of the closet yet. Sometimes, mothers of transgender people write to me. They ask me how they can help their children go through it all. I receive letters from teenagers who want to transition but don't know how to do it or how to tell their families.

I want to do something for others. I know that as a transgender person, after the surgeries I've been through, I won't have biological children, but I want to leave something behind—some evidence of my existence, a legacy. Otherwise they'll say: there was this guy, he had a sex change, he lived his life, and died.

I came out during a live stand-up show I did on national TV, but I stopped performing after that for a number of reasons, mostly because I didn't want to spend all my time talking only about my gay life. This is how I was pigeonholed. I have multiple personas inside me.

At the same time, because my story has become so public, things have become easier. I don't have to approach every single person and say, "Hi, I'm Przemek, and I'm gay." The process wasn't gradual. I admire people who take small steps. They tell their family and friends. They slowly accustom others to it. In my case, all you have to do is Google my name and there I am, with all my gay history. It's because of the stand-up and because of the book I co-wrote with a sexologist— a guidebook for gays who are in a relationship.

I get it that people joke about me, but I couldn't care less. In my view, the life of a gay man can move in two directions, depending on whether he comes out or not. The path is easier if you don't hide it. It is what it is, and you speak about it openly. It gives you more freedom. Of course, it's not perfect, but nothing is perfect. But it's easier. If someone has an issue with it, it's their issue, not yours. It's a matter of changing the optics.

I know the need to talk about it. In my case, it poured out of me. It's a bit as if you didn't have to return the money you owe because you publicly declared bankruptcy. I faced no unpleasant situations after I came out. Once, on a night bus, a *dresiarz* approached me and said, "Przemek Pilarski?" "Yes," I answered, terrified, and he said, "Respect for the stand-up."

The difficulty of coming out comes from a deeply rooted sense of guilt that stems from the Catholic Church, from our culture. Apparently, it's a script inscribed deep inside us, and we can't erase it. We can only edit it. Psychiatrists say that everything we hear from our parents, at school, or in the Church remains with us forever.

I don't think that the 2015 elections reflected any dramatic change in Polish society. In Poland, being gay has always been political. The Church »

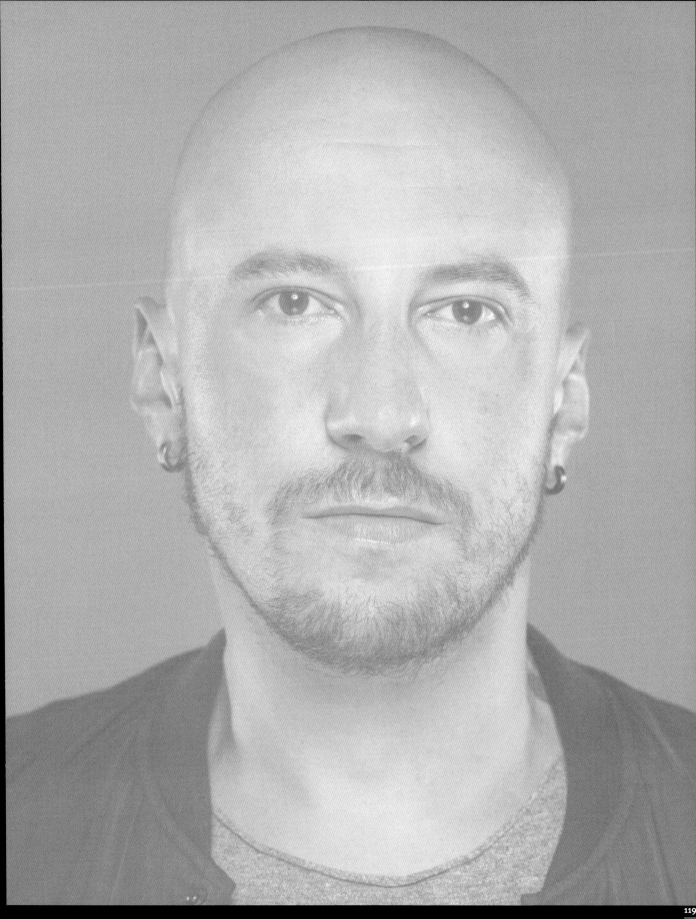

governs our country. Only the politicians change. The liberal parties haven't dissociated themselves from the Church. A bill on civil unions or hate speech has never passed, even when the so-called Left had the majority in Parliament. The main problem in Poland is the link between the Church and the state, which translates into social customs.

No one can deny that Poland is developing, but this development has mostly been for the middle classes. "Progress" has been accompanied by social exclusion. "Modern" Poland has been developing only for specific groups of people. Now, with the recent election, here comes the coarse, folksy Poland, though maybe this has always been Poland's true face. From the LGBTQ perspective, there is no difference, because we had no rights under the previous regime either.

I don't have equal rights in Poland. Even if some of us get married abroad, Poland will not recognize those marriages, which is blatant discrimination. Formalizing your relationship in Poland is impossible. There are regular pride parades, but they have little real effect. We can ride a float,

chant, dance, but we still have to be careful not to get beaten up on our way home because the police only offer protection during the parade. According to the law, you can't insult another person on the basis of race, gender, or religion, but the law doesn't say anything about sexual orientation. You can be fined for shouting, "You gypsy," but calling someone "faggot" is acceptable. But it's not. Words hurt. And they are followed by action. Psychologists use the term "minority stress" to refer to stress, even unconscious stress, experienced when a person lives under oppressive conditions for an extended period of time. To live as a gay person in Poland means to exist continuously in an oppressive environment, which can result in depression or somatization. It can also result in an inability to sustain a relationship, because those relationships, unlike heterosexual relations, are not supported by society. In Poland, non-straight relationships are a gray zone, almost illegal, almost a crime. Building a relationship is more than just chemistry or biology. My country doesn't want people like me to love and be together. Here, I am a second-class citizen.

The Orlando shooting touched a particular nerve because it took place in a gay club. I listened to the survivors saying that Pulse had been a safe space for them, a space that for some of them meant more than their family home. I knew what they were getting at. In a gay club, something slips off me. When I'm there, for those couple of hours, I'm not thinking about whether or not I'm safe. I'm free. As I heard these testimonies, I saw a comment on an online article about Orlando. Anna, a Polish mother of two, had written: "A reasonable person has never felt sorry for that scum, and never will." This is where we are in Poland.

It took me over thirty years to accept myself. I learned what "homosexualism" was from a Jehovah's Witness book, *Your Youth*. It was the nineties, when I didn't have access to the Internet. In a chapter titled "Self-Rape and Homosexuality," I read that homosexuality was a disorder brought about by bad company and bad thoughts— by Satan—but it could be cured. I read that yielding to impure desires meant that I could be excommunicated, shunned by my friends, family, and community. You wouldn't greet a person like that on the street, let alone respond to their greeting.

The Truth—as Jehovah's Witnesses call their doctrine—was brought to my family from Argentina by my great-grandfather. My dad used to be a congregation elder—the equivalent of a parson. He was a big gun in Szklarska Poręba, where our congregation numbered fifty to sixty people. But then he decided to go to his brother's wedding, where his brother was marrying a Catholic woman. He didn't even attend the ceremony, but the congregation still removed him from his position, which he had held for over twenty years.

I was born into this oppressive community and quickly embarked on the path toward a religious career. I was hoping that God would heal me. I became a regular pioneer, someone who dedicates ninety hours each month to preaching the word of God. In order to have the time, I quit high school, and I would spend almost all my days dressed in a new, male uniform—suit, tie, briefcase, *The Watchtower* in my hand. I played the part of a real man.

It was then that I met Gaja. We had been sent to teach at a Pioneer Service School, a two-week conversion camp in the Polish countryside. I caught her sniffing my shirts in my tent. She was an English teacher, a redhead, freckled, gorgeous. I told her I was gay. Together we prayed to Jehovah to fix me, to take the thorn of homosexuality out of my body. I loved her. We chose a wedding date. »

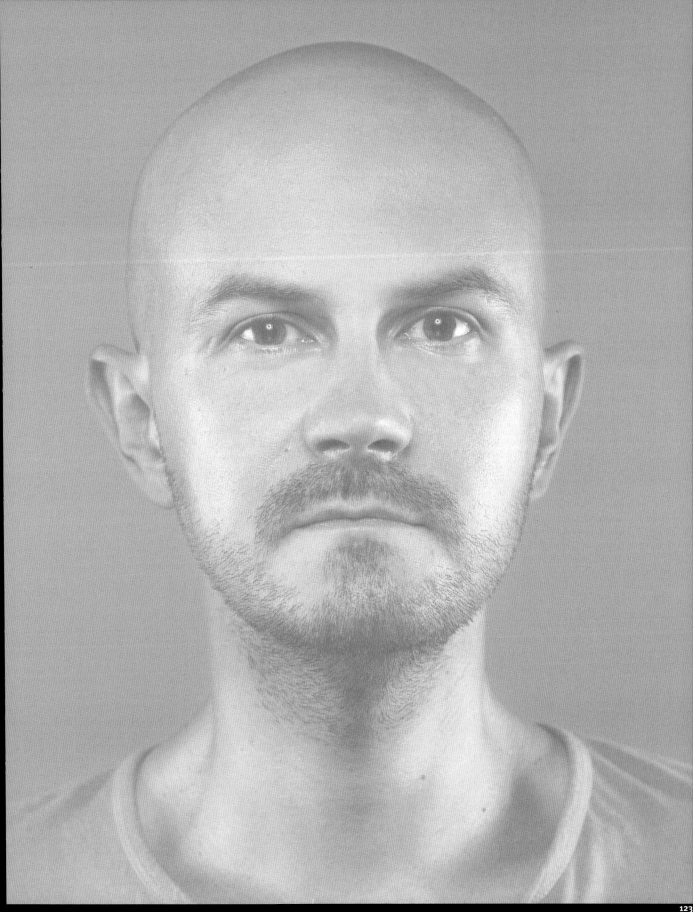

I was outed to my parents by my uncle, who was a psychologist. My parents had had a serious falling out with him, and he said, "Your son is gay!" They didn't believe him, but there must have been something in his eyes, or he must have touched on something, because after the quarrel my parents called me all upset. I'd been planning to tell them three years from then. I was living alone at the time, and I had drafted the whole process of coming out of the closet. My mom asked if it was true that I was gay. I said that it was, because I didn't want to lie anymore. They came to see me the next day with the Bible in their hands. After they left, I received two text messages from them that I remember to this day: "It would be better if you were a murderer" and "Leave that shit or you will lose us."

I broke up with Gaja. She cut herself that night. I asked my cousin to bring me drugs I had known nothing about. I started using. It lasted three years. I tried everything to drown *it* out. I abandoned religion and lost most of my family. The emptiness was devastating. No drugs, no sex, no relationship could fill it. I had learned to condemn myself and carry that contempt inside me, even though I was no longer part of that system of harmful beliefs. I was convinced I was bad, defective. I cut myself. I burned myself with cigarettes. There were failed suicide attempts. I did a lot of self-destructive things out of guilt, out of a desire to kill the part of me that was sinful.

To this day, young boys are told they are faggots and perverts. They hear it when they march in pride parades, they hear it from politicians, and even if they don't hear it, they feel invisible, ignored by the law. You can still assault a transgender person, and the police will not take down the reason for the assault, because the Criminal Code doesn't acknowledge transphobic violence.

Sophocles' *Antigone* fascinated me. Antigone knew she had to bury her brother and that she would be killed for it, but she did what she felt she had to do. It was the same with my own choices. If I chose a life with God, I would be lying to myself, and I would be unhappy. If I chose a life with a guy, God would hate me, and I would lose my parents. Now, ten years later, I am quite close to my parents, but we have hurt each other with words. It's a process. We have talked for hours and hours. They are my closest people. They didn't abandon me.

I told my friend about myself for the first time when I was nineteen. I didn't even *say* anything because I didn't have the courage. I wrote that I was gay on a piece of paper, and folded it into a small square. I gave it to her in person to see the look on her face when she read it. The second person I told was Gaja, and then nobody else for a long time. I was in the closet even when I started working in Warsaw as a journalist.

I finally described my experiences in my book, *Witness*. For many months I'd felt that I was on the cusp of telling everyone that I was gay and proud of it. But at that point, even though I no longer felt shame, I felt no pride. There wasn't anybody to be proud of. To paraphrase Simone de Beauvoir, no one is born gay, but rather one becomes gay. Gay is a costume, a sociocultural construct like male or female. I wear it for the sake of this story, but I don't believe in it.

Gay men, much like straight men, sometimes create their own homocentric communities that exclude women of any sexual orientation, that sometimes implicitly accept the violence and discrimination they face. Those stifled by the Church, by family, by teachers, by their peers, those persecuted because of their looks and desires, suffering to the point of fantasizing about death, sometimes build their identity on the unjustified pride of being different. A lot of gay men also aspire to a better world, with rights and freedom, not seeing that it is a male world they aspire to, which doesn't leave room for difference.

Coming out publicly has opened a new chapter in my life. I now have the freedom that I didn't even know existed. I have self-respect. I have deepening relationships with my loved ones. I have fallen in love with life.

People have wished me dead, but it's so common here that it doesn't bother me anymore. The erasure of LGBTQ people is ongoing. The Polish heteronormative world is steeped in chauvinism. I'm not saying it ought to be a gay world instead. I don't want us to have more rights or different rights. I want to be able to love and to hold my boyfriend's hand when we walk down the street. I want our existence to be acknowledged.

Silence can be homophobic. If we witness a wrong done to another person, we should respond. We are obliged to by law. We are, in Poland, witnesses to the violence and discrimination directed against LGBTQ people. For that reason, in 2016 I wrote »

an open letter to public figures who identified as lesbian, gay, bisexual, or transgender but who were still in the closet. It was signed by 115 high-profile people who had come out. It was covered almost everywhere in the Polish media, and it started a debate. But a lot of celebrities, writers, actors, film directors, and musicians are still in the closet. Activists fight for our rights, and they are the ones taking a beating. I remember how significant the movie *Philadelphia* was for me—I devoured it like a starved dog. I remember a famous journalist who came out when I was a teenager. It's a pity that so many people still prefer to stay in the closet, implying that it pays to play the straight game.

Today, I couldn't be with someone who lives in hiding, who doesn't respect himself. I love freedom. I was afraid of coming out, and so I understand that it's always a difficult, individual process. At the same time, it's just fear that's holding you back. I am against outing people, or even denouncing homophobes, because both are violent acts. But I won't stop encouraging high-profile figures to show courage and come out. They can contribute to real change. Becoming free of fear is like dancing, like looking into one another's eyes during orgasm—it's indescribable.

After all, ever since Harvey Milk urged us to come out, we have known that visibility is the way toward emancipation.

I have experienced many forms of exclusion. I was excluded from the male tribe, excluded from religion and therefore my peers, and excluded from my family because I abandoned religion. I have been made to feel "other," to feel as though I were a worse human being, to feel as though my sexual orientation were a sickness. The only thing that keeps me with another human being is love. It used to be a belief system, or fear, shame, guilt, desire, gender, or sexual orientation. They still matter, but they no longer have the same power.

I am not a man, even though I like my body, my penis. I am not a woman, though I'm most comfortable among women. My deepest and most intimate friendship has been with my female cousin. I've known her for more than thirty years, and she is the love of my life. She was the first one to know I am gay, and we continue to share everything except sex. I am not straight. I am not gay either, because that word is confining. Even though I am sexually attracted to men, I also fall in love with women. Of the letters LGBTQ, I feel closest to the letter Q. I don't believe in gender. Gender is nomadic. Nothing is permanent.

I've always felt I have to be true to myself and not dance to anyone else's tune. I don't need to define myself to myself. If I had to describe myself in ten words, the word "gay" would probably make the list, but I'm rarely in a situation where I have to do that. My friends know me, and I don't feel the need to talk about my life with people I don't know well or in formal situations. That said, when you interact with strangers, there's still the default assumption of heterosexuality, and so to stop being ascribed the wrong sexual orientation, gays and sexual minorities are forced to articulate their identity.

I grew up in the eighties. I discovered my sexual identity in the early years of my adolescence. I became aware of my desires in elementary school, and gradually I became familiar with them, explored them. I liked dressing up, playing a role. This set me apart at school. Once, on the first day of spring, my male friends dressed up as pirates and sailors, and I came dressed as a girl. I didn't realize that it might be frowned upon.

In high school, I was fully aware of who I was, even though in those days it was taboo. The subject would be mentioned only in a negative context, often in relation to crime. But I quickly discovered films and literature that confirmed that being gay was something exceptional. It made me feel special. It tickled my vanity, even if I was lonely. I stood out against the gray Polish masses. I felt like I was part of a unique community, in good company. Shakespeare, Michelangelo—I would write down the great names from the pantheon of culture, but in books "homosexualism" was still presented as a flaw, a kind of tragic destiny. I was torn, but I didn't lie to myself. Because I am an introvert, I kept it to myself. I confided only in my best friend.

My peers openly rejected me. I had to face offensive accusations because I didn't entirely fit the masculine norms. I was different. I didn't like soccer, and from that, it's an easy step to "You're probably a faggot." Even within the gay community there's a lot of homophobia. You have to fit the norms of popular culture, which is very masculine, patriarchal. You can see it on online dating sites. You have to be masculine: "Beat it, queens!" I don't think about whether I'm masculine. I'm not trying to prove anything. »

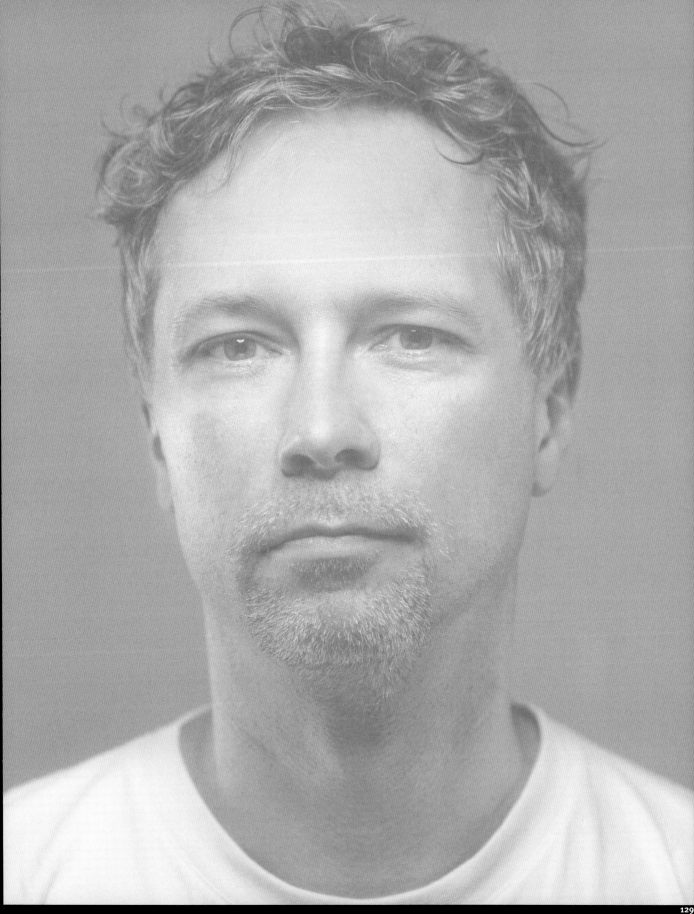

In Poznań, my city, the LGBTQ movement emerged rather quickly, but I wasn't part of it, because I felt that my sexuality was my own private matter. Poland didn't have a tradition of social activism. As a country we were just shedding the yoke of communism. Finding a partner wasn't easy. These days there are apps and websites. You can go out and find a gay person. Back in the day, nobody was discernably gay. I wasn't sociable. I didn't even go to school parties. I didn't hang out in a park to find a boyfriend. I didn't go to clubs, because I didn't know they existed. It was just me and books. I reached graduate school with this secret inside me. I was reconciled to my own sexuality, but at the social level I stayed in the closet. That was what Polish hypocrisy was all about—everyone pretended you didn't exist.

I slowly came out of my shell and began functioning socially as a gay man. It was a process. Coming out to my parents was very dramatic. My parents found out that I had a boyfriend in grad school. Someone must have told them, maybe a jealous friend. I never looked into that. My father had a talk with me, which wasn't pleasant. In those days, people believed every gay man had HIV. My father started attacking me verbally. He told me I should get checked. I slammed the door and moved in with my partner. I didn't speak to my parents for two weeks. Later, they extended the olive branch. They are both seventy now, and I still sense a barrier, a fear of what people will say. They seem to accept me, but they don't tell me that. They seem to accept my boyfriend, Maciek, but they have never treated him the way they treat my sister's fiancé, or the way they would treat my wife if I had one. They've never suggested that Maciek should address them by their first name or as "Mom" and "Dad," the way that straight people do when they become a family. They've maintained a distance. They haven't lost the feeling that this is something strange. It is difficult for them to learn something that wasn't part of their upbringing and that's socially condemned.

I became an activist in the early 2000s when "homosexualism" was still a term that was used, usually with dislike, condemnation, or pity—I'd take condemnation over pity. LGBTQ and gay organizations were sluggish. They concentrated

on AIDS prevention. But I was angry. I felt I wanted to do something. So, in 2001 I started Kampania Przeciw Homofobii (Campaign Against Homophobia). I came out publicly and wrote a book. I encountered resistance because people didn't want to know. Ignorance is bliss in Polish culture. We prefer the pretense of not knowing. I remember complaints that I was trying to make something that was marginal, niche, into an issue of national importance. Public figures came out, spoiling the convenient media image of "faggots" and the idea that we are somewhat exotic: "They exist somewhere out there, but we have no contact with them." Polish people didn't want any sexual minorities to enter public discourse, and, if they did, they wanted to set the terms: let them be, but let them stay in the closet. I gave an honest interview in which I said that I don't always get along with straight men, because they patronize me. People scoffed that I divide people into gay and straight when "after all, it doesn't matter."

My first angry article was in response to a discussion in a Catholic monthly that was full of fake sympathy. I was angry that four men were voicing their opinions about us, each an authority in their own field, and none of them gay. TV was the same. Even until a few years ago, politicians, priests, and psychologists would speak about the pride parade without inviting anyone from the LGBTQ community to participate. My activism was born from being so pissed off that people were speaking on my behalf, making decisions on my behalf, without letting me speak. They presumed to know who I was and how I should act.

A year ago, I would have said that the fight for civil unions was the most important concern of the LGBTQ community here, the fight for legal regulations that would allow the citizens of this country to put the most basic elements of their life in order. Now, I think that we should prioritize fighting hate speech, hatred, and the growing xenophobia, which could turn into physical violence. Political change has galvanized those who thrive on homophobia, because now their views are mainstream. It's important to resist them. It's important for all social movements and organizations who say "no" to that vision of the world, and for Poland to come together in solidarity.

Edward Pasewicz

I am a Polish poet, writer, and columnist. I write novels, plays, short stories, and music. For a long time, I have also been openly gay. I came out when I was fifteen in Międzyrzecze, a small town in western Poland. In this way, I helped other people in the town come out, too. I didn't face any problems from my family or from elsewhere because of it.

I run Scene 21 at Kraków's Queer Cultural Center, and I chair the Queer Cultural Center Association. It's an organization dedicated to culture, broadly speaking—from music to theater. Its main goal is to introduce the heteronormative world to what's going on in the non-heteronormative community. The plays we put on are not all queer, and the actors who perform on our stage are not all gay. Still, I'm sometimes on the receiving end of online abuse because of what I do.

Things turned worse the moment the Law and Justice Party implicitly gave the nationalist, fascist elements in Poland permission to operate undisturbed. The previous governing party also treated artists and the LGBTQ community with contempt, but they did it wearing kid gloves. The problem is our Polish mentality and the Catholic Church. In this country, if you're different, you'll find there are a lot of people who drag you back

in line. This is how things were in the People's Republic of Poland, and this is also how things are today. It's our national trait: if someone is talented, we put obstacles in their way so that they trip and fall to pieces.

Artists, LGBTQ people, and foreigners are similar in their lack of rights. In this country, difference terrifies people—everyone should be the same. The point is not to stick out too much. It's a result of partitions, uprisings, World War II, communism, and the fact that in March 1968, the intellectual elite was decimated by the expulsion of Polish Jews.

Culture created by young artists is more important for identity than national culture is. Culture helps you become familiar with difference. It requires openness. We are still mostly a peasant society. If a family lives in a city, it's at most for two generations. A village mentality and peasant instinct for self-preservation keep the countryside together, make its rules, and secure it against anything new that might come from outside, because anything new is threatening. Everything that destabilizes existing structures has to be immediately eradicated. This is the most prominent feature of our society. People think once gays get their rights, society will fall apart. Nobody even wants to consider whether thinking »

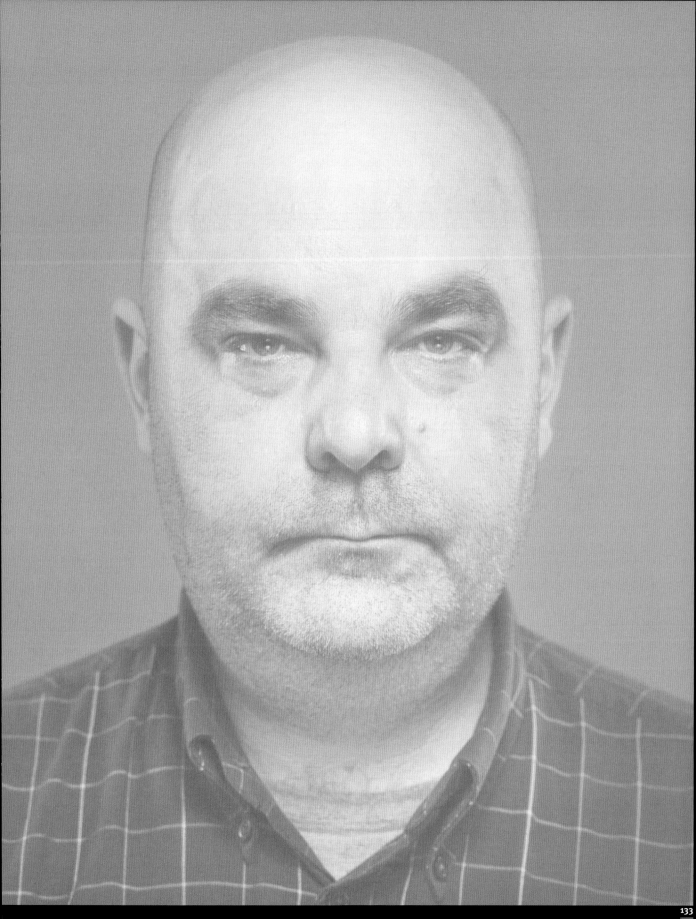

this way makes any sense. If they took the time, they would realize it's not so frightening.

The situation of gay people in Poland is tragic. We have no legal protections. When I was in hospital, my partner of eleven years, Łukasz, couldn't receive any information about my condition. We live together but we cannot file our taxes together. These are everyday matters. More significant, we don't feel safe. I can't walk down the street holding Łukasz's hand. We can't eat from the same plate at a restaurant. We'd like to do that, but not here because they'll beat us up again.

We were coming home from a bakery. I affectionately gave Łukasz a piece of a sweet roll. A young man approached us, his hand bleeding, and asked if we had a tissue. I asked Łukasz to hold my shopping bag and reached into my pocket. At that moment I felt the first blow. A second man took care of Łukasz. Then, I was lying on the ground, my teeth knocked out, and they were both kicking me without saying a word. They were completely ordinary twenty-something-year-old men. Their pastime was to stand in the street on a Friday or Saturday night threatening and robbing gay men coming home from a popular club. They knew who they were assaulting. They were caught when they attacked someone else the next day.

A young man, Eryk, once came to me. He told me about his psychopath father who had told his sons to learn the Bible by heart. Whenever they behaved badly, they had to finish from memory the verses their father began reciting. If they made a mistake, the father would send them to sleep on the dirt floor of the garage. Eryk was defiant. He often ended up in the garage, where he befriended the rats. At seventeen, he ran away from home. When his brother, now a fascist, found out that Eryk was gay, he got a nationalist hit squad linked to the National Radical Camp to vandalize a gay club where Eryk worked. He warned Eryk he was going to beat him up so badly that he would give up being a faggot forever. The police were notified, and any violence was avoided. I wrote a play about it, *Dzikie Szczury* (Wild Rats).

I know young men whose parents are supportive. For instance, there's a man by the name of Nikodem, an intelligent, wonderful man, without hang-ups. His father appears on TV as a parent of a gay child. I also know a young man by the name of Sebastian whose father doesn't know his son is gay and whose mother and sister make sure he doesn't find out. Sebastian takes his female friend to family gatherings, and she pretends to be his girlfriend. I'm not going to say that young gays have it easier these days.

I've noticed how men treat us transwomen. They act as if we have betrayed the male species because, after all, you must be seriously fucked up to renounce masculinity. Not all men treat us like this, but most of them do, and we don't want to have anything to do with them either. At the same time, we don't necessarily have a buy-in into the world of women, either. My impression is that many women don't believe that our femininity is honest, that we truly feel like we are women. For men, we are traitors, and for women, we are spies from the men's world. It's not that they don't accept us. It's more that they don't want to fully let us into their world. We are allowed in their kitchens, but not in their living rooms. I know that it's a very disappointing experience for my transgender sisters. I've encountered it myself. We are on the margins of both genders.

We are excluded by gays, lesbians, bisexual, and straight people. Bisexual people need gays and lesbians. In turn, gays and lesbians look down on bi people. They say they are, in fact, gay, but that they just haven't defined themselves yet. I've personally experienced a lack of acceptance in the gay community. On the one hand, they treat us as if we were men, but on the other they say we're not worthy of the name—as if we were nothing more than a piece of meat to screw. They reduce the whole issue to the penis, which I have, and beyond that, you're a whore, a bitch, a pervert. This is what we were called in one LGBTQ club.

I'm out as much as you possibly can be. I am a transwoman—a woman whose gender was defined at birth as masculine. I've always felt I am a woman, even though I've spent most of my life as a man. I am forty-nine. I started my transition three years ago. The process was intensive at first, but later I had to slow it down. At the moment, I am only going through the medical part of the procedure.

Transition is not solely a medical procedure. It takes place also at the social and professional levels and permeates every sphere of your life. I discarded my masculinity at a much earlier stage. I started assuming the role of a woman when I was working. It was very difficult, but it became easier when I joined the Trans-Fuzja Foundation and became a transgender activist. I was anxious and afraid. You can't change your gender role overnight. In my case, the so-called Real Life Test—the period when we have to live in our preferred gender role—lasted a long time, but I »

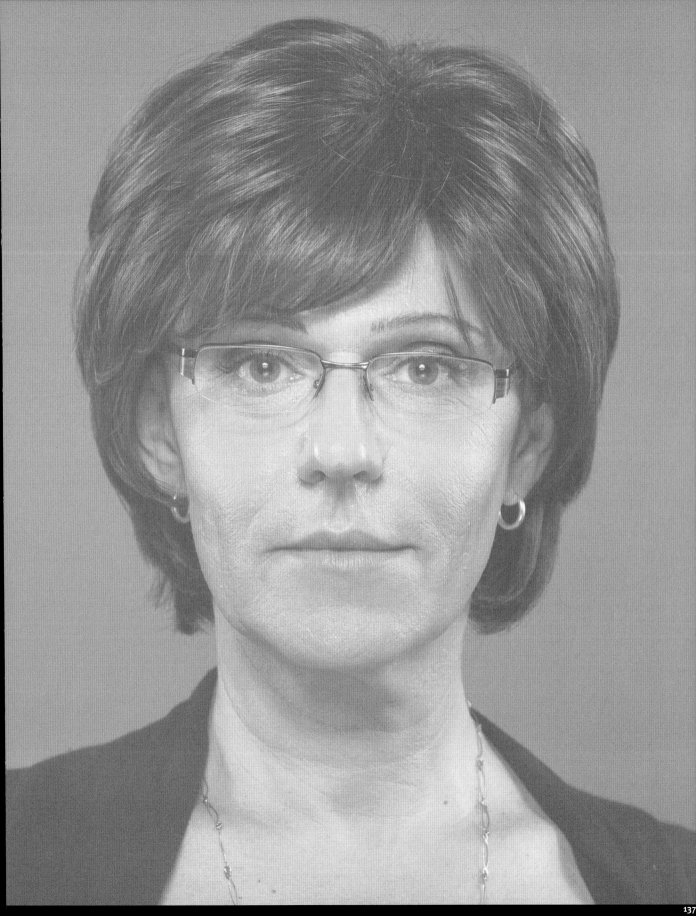

passed. I feel good. Some doctors require that the test be taken without any treatment or hormones before they issue a diagnosis. Even removing facial hair can be out of the question. How can you feel like a woman with heavy stubble that even a ton of makeup can't cover? But this is what some doctors want. These procedures have been abandoned by doctors everywhere else except in Poland. It's inhumane that we can only live in our preferred gender with their permission. I know beautiful transwomen who feel insecure because they have to walk around with a prominent Adam's apple. We need speech therapy sessions to help us develop a female voice. Instead, physicians send us out into the world and tell us to be women without the aid of gender reassignment therapy. It's the same for women who want to become men.

Everyone should be able to decide their own gender identity. We should be able to officially register ourselves as men or women. You have to be able to function in society as yourself and to have documents that attest to that. It's a complicated process in Poland because we are treated as if we're taking an exam in being a man or a woman. The same standard doesn't apply, for instance, to parenting. We become parents even though I think 99 percent of society is unfit

to be parents, and yet you don't have to pass an exam to become a parent. But I have to take a form of exam if I want society to recognize me as a woman. Meanwhile, courts inquire about our sex life, which violates the constitution. Gender reassignment is about gender identity, not sexual orientation. I have a right to keep my sex life secret.

At the Trans-Fuzja Foundation I am responsible for the mail. I was granted authorization to work there based on my ID as a man. There is still a disconnect between my documents and how I present, and when I started there I was afraid there would be complications at the post office. I carried around a second set of clothes. I would come to work as a woman and then change into male clothes. I would go out, run errands, come back to the office, and turn myself into a woman, and that's how I would function for the rest of the day. When the female clerks at the post office stopped asking to see my ID because they knew me, I decided to do an experiment. I showed up dressed as a woman and was able to pick up the packages. They'd seen the foundation's stamp and they knew that Trans-Fuzja was working for transgender rights. Now I go to the post office without any problems. A new clerk started working there last month. She asked to see my ID and was

dumbstruck. She went to the back to check my personal information. I was waiting at the counter for twenty minutes. She came back, looked at me closely, asked if I had the foundation's stamp, and only after she saw it did she put everything together.

I dedicate myself and my coming out to the next generation of transgender people. I hope it makes it a bit easier for them. It's difficult for transgender people. It's partly because of ignorance here, the burden of religion, and backward worldviews, but it's also because of the attitude of transgender people themselves. I see a dramatic difference between what's going on in the world and what's going on in Poland. Outside of Poland, transgender people understand better that they have interests in common with other transgender people. Not so in Poland. Different cliques have emerged in the transgender community, and each wants to prove its point. Some are less radical than others. I admit that we have created this situation ourselves. There is, for instance, a group of people who very aggressively defend their position as "true transsexuals." They believe that there are transsexual people and transgender people. In their understanding, a transsexual person has to go through gender reassignment from the beginning to the end:

diagnosis, followed by hormone therapy, meaning therapy that recommends the highest hormonal dosage, followed by correcting all legal documents, and finally male-to-female or female-to-male genitoplasty. If you don't do that, you're not transsexual, according to them. They also use sexually normative categories. They don't accept the existence of transsexual people whose sexual orientation is anything other than heterosexual. If I want to be a woman, then I must want to have sex with a man. That's not how it should be. According to Western medicine, the sexuality spectrum among transgender people is as wide, if not wider, as in the rest of society. It's a question of human rights. Each of us has the right to express his or her or their own gender identity, regardless of whether it is female or male, or fluid, or gender-free. Everyone has the right to do what they want. "True transsexuals" think there is only one way. They want to remain invisible during transition. They think the perfect transition is one in which you transition from male to female in a way that no one will know that you were once a different sex. In my opinion, you have only one life and you cannot erase any of it. I have behind me years of professional work, my name, accomplishments. I don't want to lose that. Why should I give that up?

Poles don't cope well with difference. We're not curious about it. We're not interested in what is valuable about difference. The Church bolsters this attitude. It imposes outdated theories on society. It is always bothered by minorities and people who want to live differently, on their own terms. It wants tradition. Family means mother, father, children, and a home. But people often get tired of playing roles that don't reflect their reality. They want to live in their own way. The definition of the family is changing, too. It's not an accident that 25 percent of children in Poland are born out of wedlock. We're no different than other European countries, but here the burden of tradition is enormous. Even commercials exploit the "holy" model of the family. The new government reinforces this worldview even more. It launches attacks against difference. It projects Polish backwardness onto strangers. Immigrants, it says, are bad because they spread germs, and gays and lesbians are incapable of forming families. But a lot of the hostility of the Law and Justice Party is directed toward people who are Polish citizens and who are lesbian, gay, bisexual, trans, or queer. There is a lot of misunderstanding, distancing, lack of dialogue. There is little empathy.

The headquarters of Lambda Warsaw is in the center of Warsaw. Since 2011, there has been an Independence March each year on November 11. Originally a national celebration, it's mostly a gathering of militant, nationalist, right-wing, and fascist organizations marching through the city with national flags, firing up flares, and destroying most of what they encounter along the way. It's a riot that has nothing to do with celebrating independence. The windows in our building have been broken twice during the march. Last year, our new headquarters and the Kampania Przeciw Homofobii offices were vandalized for the first time for no apparent reason. Someone, or some people, had attempted to break in, had thrown stones through the windows, and had damaged the doors. We notified the police. They increased their patrols. We'll see how it's all going to end.

These are deliberate attacks on the largest Polish organizations acting for LGBTQ people. You can link this violence to our government officials, who promote hate speech toward our community, who close down agencies handling minority affairs. People get wound up because of what they hear in the national media—that being gay is a sickness, that gays are shameless and unbalanced, that »

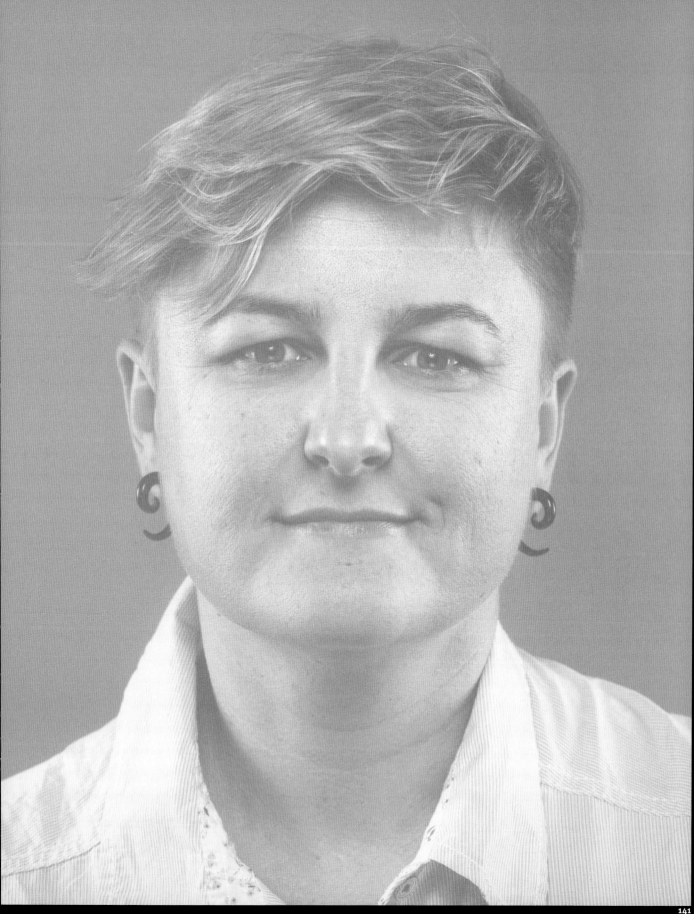

they don't live past the age of forty, and that they are pedophiles. It's easy to take aim at a stigmatized people, to take your anger out on them. We've always had a lot of problems, but I feel there has never been so much hatred.

I am one of the first people in Poland who came out publicly. People who decide to come out are afraid they will lose friends, that their family will shun them, that they will be thrown out of their apartment, or that they will lose their job, but I don't know a single person whose life has been worse after coming out. They can live fully and honestly. They don't have to pretend, to live a double life. It is psychologically reassuring. I think the process of coming out is ongoing. There will always be a person who will ask you about who you are from the start.

When I came out for the first time, all I felt was terror. I was persuaded by a friend who was writing an article about atypical couples for the magazine *She*. It was 1998. Later, my partner and I appeared on TV and on the cover of *Newsweek*. There were posters for that issue hanging in many places around Warsaw. I was afraid everyone would recognize me, but I was wrong.

In 2002, gays and lesbians were a hot topic after the controversial *Niech nas zobaczą* (Let them see us) campaign.

My family struggled. In the nineties, it was something new for them. They had to grapple with it, ask around, read up about it. They are rather open, but the conversations were difficult. They were all on their own. My mom was asked by her neighbors, at work: "That daughter of yours, what is she doing?! She's on TV talking nonsense. Do you accept all that?"

The LGBTQ movement started in our country around that time. Lesbians have been barely visible from the very beginning. They have experienced a double stigmatization. They are gay and women living in a patriarchal society. Men have chaired LGBTQ organizations for many years. For a few years, Lambda Warsaw was chaired by a woman. Women have taken up the reins in many organizations. It's a good sign. There is so much going on that every day I receive at least a few phone calls about LGBTQ issues. If I did it for a living, I would be exhausted, so even though I do a lot, I don't dedicate my whole life to the cause. Doing it 24/7 would wear me out.

Anna Grodzka

For me, there never seemed to be a good time to become a woman. At times it was too early, at other times too late. You need enormous determination to do it before puberty, but it would be great if a young person could enter their adult life as the gender they actually are. Then, you can transition without upending your entire life, your relationships, your children. Genital reconstruction—not "sex change" surgery, as it's often referred to as—is not always the most important step. Gender reassignment is a process involving a broader sphere of one's life.

I turned eighteen in 1982, and I had no idea that gender reassignment was possible. I knew that I was a woman, and I thought I was the only person in the whole world to be like that. I thought I was crazy. I didn't know anyone like me. I hadn't read about anyone like me. At that time in Poland there was barely any information about it. Later, you might hear some sensational news that somewhere someone had surgically altered their gender. Then, Ada Strzelec's book *Byłam Mężczyzną (I Used to Be a Man)* came out and made Poles realize that gender reassignment is an option. At that point, I'd been trying to live as a man, and I was in a relationship with a woman. I

knew that stepping into a new gender role would be extreme. After all, I had raised my son as a man, and the woman I was in a relationship with meant a lot to me. The final decision to transition came after I divorced my wife—eight years ago. If I hadn't lived as a man for so long, if I hadn't decided to transition so late, if I had known that I was in a relationship with a woman who wouldn't accept this, our breakup wouldn't have been so painful.

I am a clinical psychologist by training. When I learned that gender reassignment was possible, I read everything on the subject. I decided to set up Trans-Fuzja (Transfusion) in order to let society know that transgender people are born among us and live among us, that they have the same right to be themselves as cis people do, and that they cannot be inhumanely deprived of that right. It wasn't easy to get that message out in the media. I would appear as a man who was an expert on "those issues." They would ask me if transgender people were members of the foundation. I would say, "Yes, they are, but they don't want to reveal themselves publicly." For a gay person, coming out is beneficial because they can start living openly and form honest relationships. A »

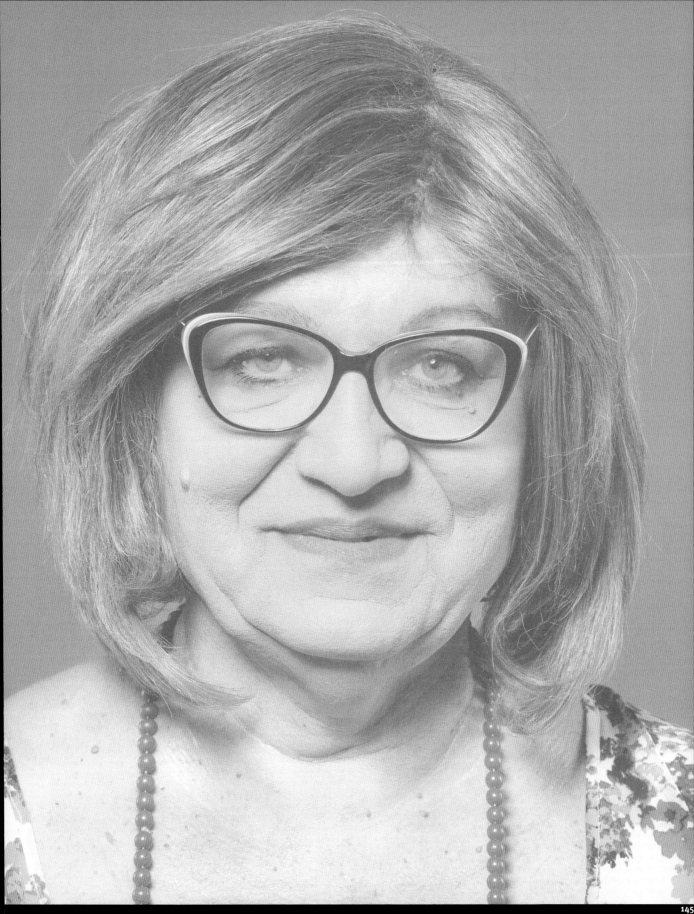

transgender person forms genuine relationships only when they are their true gender, not when they come out as a transgender person. Realizing how difficult it was to reach the media, I decided to come out as a trans person for the sake of the foundation. They would listen to me and my story, but, in the process, I became the "token" transgender person. People see me in the street and say, "Look, this is Anna Grodzka, that transsexual." Nobody says, "That woman." I had to choose between the mission of the foundation and the quality of my life. I could have tried to simply be a woman, without coming out, but I didn't, and our society's awareness that I am someone who used to be a man continues to be a big burden for me.

Since I came out, people in Poland have become more aware that transgender people are among them. They don't yet know how many, but it's no longer beyond the scope of their imagination that someone in their family might be transgender. More people think about how to help transgender people be themselves; they appreciate that someone is fighting for transgender rights. But at the other end of the political spectrum there are

those with the opposite convictions. I get a lot of positive messages from people I don't even know, but I also receive messages filled with hatred. If I didn't have support, I would try to emigrate or hide myself away.

Why did I go into politics? I had already come out while I ran the foundation, and politics felt like a continuation of that trajectory. I thought we would have a chance to show Poles that a transgender person thinks in the same way that most people do, doesn't have a tail or horns, doesn't spit fire, and might even share some of their values.

I've always been fascinated by politics, which I understand not as a form of power, but rather as the art of creating certain conditions, a vision of the world. I support getting rid of difference and inequality, including economic inequality. The climate in Poland is becoming more and more radical. It's frightening. The governing party is trying to institute authoritarian rule. They don't have a constitutional majority, and yet they're trying to pass unconstitutional bills. The position of the Left in Poland is still weak. We need a true Left here that is liberal and open in its world and social views.

Coming out is not a one-step process. We continue to come out throughout our lives because we are a minority in a society that assumes everyone is straight. It's a pity that the reality is so damn difficult, that it's so hard to go through this process unharmed, that we even have to organize coming-out days. Straight people live in a kind of hetero-matrix. They don't have to think about their sexuality. For them, it's like air. Meanwhile, it's a nightmare for us. We have to endure the idea that our sexuality is something unnatural. The first step is always the most difficult: sorting out your innermost feelings, struggling with an identity that is at odds with society. The most difficult thing is to tell yourself: "Yes, I am gay, I am a lesbian, I am transgender."

In my case, I didn't just wake up one day, state I was gay, and from then on everyone knew about it. For me, it was a very long process starting from when I was outed. It wasn't my decision. I was eighteen. I was taking the admission exam to the University of Olsztyn. When I came home, my mother told me that a young man I'd met in Olsztyn had called and said he was in love with me and that he wanted to be with me. My mom couldn't understand why a strange man would call to tell her that he loved her son, and she asked me what this was about. I pretended I had no idea. Unfortunately, he called again a few days later and explained more explicitly to my mother what it means for a man to love another man. It was too late to deny it. I had no choice; I couldn't hide who I was anymore, and so I told her that I was gay.

Today, gay is a more neutral term. Back then, you would say "homosexual." My mother couldn't say the word at all. It would stick in her throat. She kept asking: "Are you, well, you know, that?" I couldn't call myself "homosexual" either. So, I told her I was "that." I think it was one of the most difficult days in my mother's life. For her, it meant her son was dead, that this man was no longer her son. She was in despair. The last time I saw her so devastated was when her parents and my father passed away. She didn't know how to cope with this at all. She didn't know anyone who was gay. She had no idea how to process it. She had seen the movie *Philadelphia* and kept saying that I would die of AIDS. Back then, in Poland, nobody actually talked about AIDS; all she knew came from TV and books. She knew AIDS was an illness, »

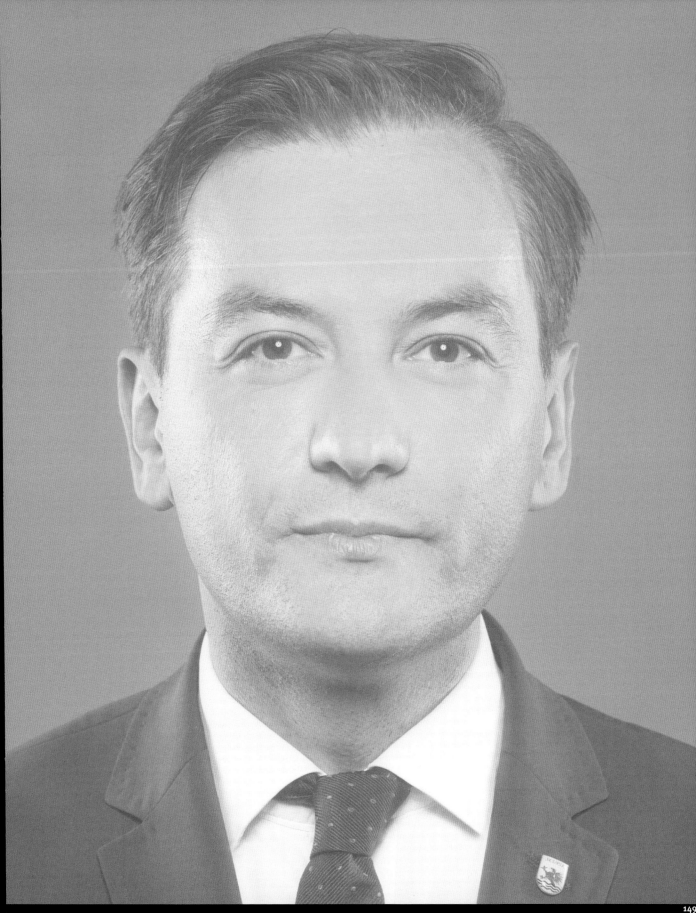

that gays died of AIDS, that they were lonely, and so she kept saying that I would be lonely all my life. But what mattered most to her was that I didn't tell anyone. What would the neighbors say? What would our relatives say? She begged me not to come out. As a matter of fact, I wasn't prepared to come out. I hadn't processed it either. But after this, I was determined to find the courage to sort everything out for myself.

I hitchhiked to Berlin, where I met a man and fell in love. He was my first love. I discovered a new life. I saw that in Berlin being gay or lesbian wasn't an obstacle to be overcome. I saw a different world and began to dream that this could be my life.

I think I've always been someone who has to work at full capacity whenever I become involved in anything, and so at university back in Poland, I became active with Lambda. There, I encountered gays and lesbians terrified of coming out. They were often married, had families. We would meet in the evenings at Monar,[8] which had an LGBTQ helpline. I soon realized that no one outside the community knew about it, so I visited every media outlet in Olsztyn and said that I would like everyone living in Olsztyn to know about the helpline because it could help a lot of people. Everywhere I was met with astonishment: "Gee, are there gay people in Olsztyn? We thought no one like that lives here." I was shocked. One press agency responded positively. We published a supplement to the local newspaper. We also arranged a radio broadcast where we told listeners that there were LGBTQ people in Olsztyn and described what lives were like (we didn't name anyone). I was elated. I thought, "I can do great things, I can help somebody else. I am not alone. There are others."

While I was still discovering who I was, I was convinced that there was no one else like me. I grew up near the woods, in Ustrzyki Dolne in the Bieszczady Mountains. I saw bison, wolves, lynxes, and other native species, but I'd never come across another of my species. I didn't know any other gay person. I was convinced I was the only gay in the village. It was the main reason why I contemplated suicide—because I started to realize that my life would be awful. I was trying to deal with it. I would read anything I could lay my hands on, and I discovered terrible things: that it is a sickness, a perversion, a deviation. Later, I heard a priest say that it was a sin. When I played

[8] Monar is a Polish NGO supporting people in difficult life circumstances, including the homeless, people with drug and alcohol addictions, and those living with AIDS.

soccer with friends and the other team scored a goal, others would yell that I was a pansy, a fag. And if you're a "pansy" or a "fag," these words make you feel even more vulnerable. I would think: "I don't want to be that person. I don't want to be sick." Deep down, I felt there must be a different world, that there must be something else. But in Ustrzyki Dolne, there wasn't anyone like me. There was no coming out. It was a very difficult experience for me.

I know how important it is to talk about it, to help and support others, to respond to letters from kids who write to me when they discover who they are and are happy that I set an example. I had nobody to write to or call. Support is crucial so that kids don't commit suicide, so that we can avoid more tragic deaths such as Dominik Szymański's. We don't know if Dominik was gay or not—he was too young—but other kids thought he was, and that's why he hanged himself.

I don't want anything like this to happen again. I'm happy to have survived, but I know how difficult it was and what I had to go through to be able now to sit in front of you as the mayor, with my life in order—maybe not entirely in order, because this is an ongoing process. Even I can't

live openly, and there are moments when I realize there are things I cannot do. For instance, I can't hold my partner's hand in public. I can imagine what would happen if I did. You can't have dignity if according to the law you are a second-class citizen. It's stigmatizing. The state that signals that I have fewer rights than other citizens have determines the thinking of the whole society. It isn't illegal to openly call for the death of all gays in Poland, but it is to issue death threats directed at Jews or Catholics. I, the mayor, can officiate the wedding of a straight couple, but not a gay couple. It's absurd that each month I officiate about a dozen weddings while I myself can't marry my partner of fourteen years. I am resilient, but for many people it's a message that you're worse, that you have fewer rights. And, in practice, you do have fewer rights. My partner and I regulated our affairs legally, we have a will, but I have no right to decide what happens to my partner after he dies or where he is buried.

I have a simple wish to live a normal life, and I know that if I am to live with dignity, I have to encourage reflection in our society. It isn't easy. I receive the most negative comments from my own community, the LGBTQ community, which is »

probably a common experience for any activist. Even until recently, I would receive offensive and discouraging letters from gay men and lesbians. At first, I couldn't understand why. I thought that acting against homophobia would improve our lives, that we would be happier. I expected support from people with less courage to act. But that wasn't the case. They tried to drag me back. Now I know why they acted that way. If you live a life with no immediate alternatives, it's hard even to grasp that another world is possible; you assume prejudice and stereotypes are how things are. I don't feel resentment, because this is true for most groups. Some women hate feminists. Some Romani hate Romani activists. Any trailblazer will be dragged back by that part of the marginalized community that has little energy to fight. Those who fight for freedom are always few and far between.

These days, I receive a lot of positive messages, but it's been a long journey. Some used to say I was too effeminate and that I didn't represent all gay people. Others claimed that I was too masculine. I've realized I can't make everyone happy. I've fought many battles with people who have claimed that transgender people should be excluded from pride parades because they would spoil our image. But I knew that if we didn't let them in because they look different, then at some point someone else could say, "We're not letting Biedroń in because he looks different."

Today, I know I was right. I'd never go back into the closet. This issue is so important to me that I always strive to live with dignity, with personal integrity, and stay true to my identity. I've experienced so much happiness and freedom that I'd never go back. The whole process was so uplifting that I know I haven't wasted my life. You may become a mayor, or a member of parliament, but I'll never be that "disgusting faggot" again, because I now have my pride and dignity. I know that I've done something to improve my life and the life of my community. We won't easily be put back in the closet. A lot of people have gotten to know us and understand that the stereotypes make no sense. I see this change in my mom. Today, she is very proud of me. She knows, too, that I won't be alone because she knows my partner, Krzysiek, and knows that we'll likely stay together. And if I ever die of AIDS, it's not because I am gay, but because anyone can accidentally contract it.

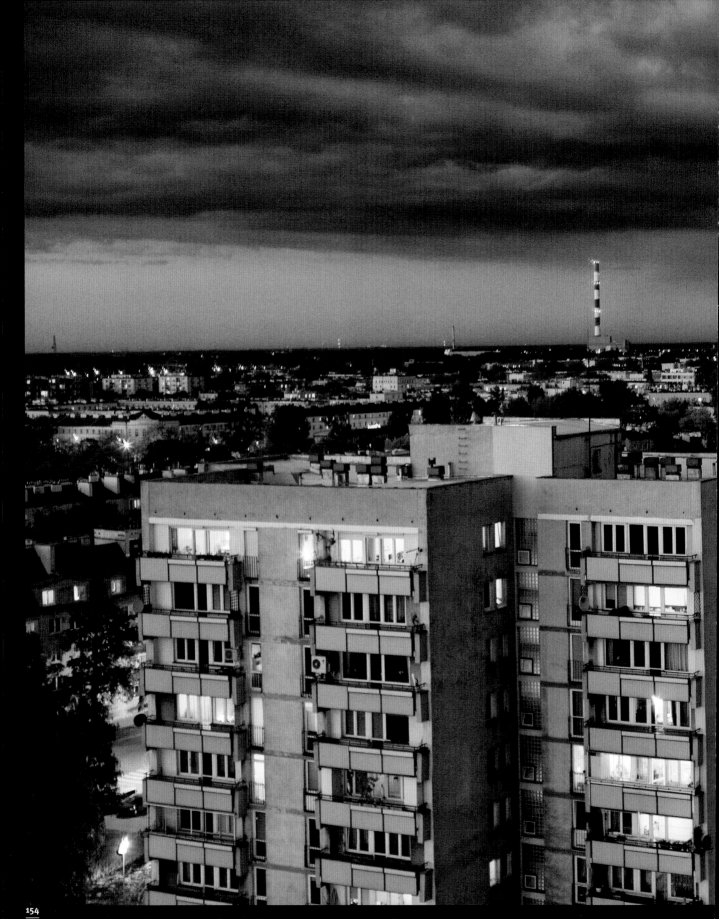

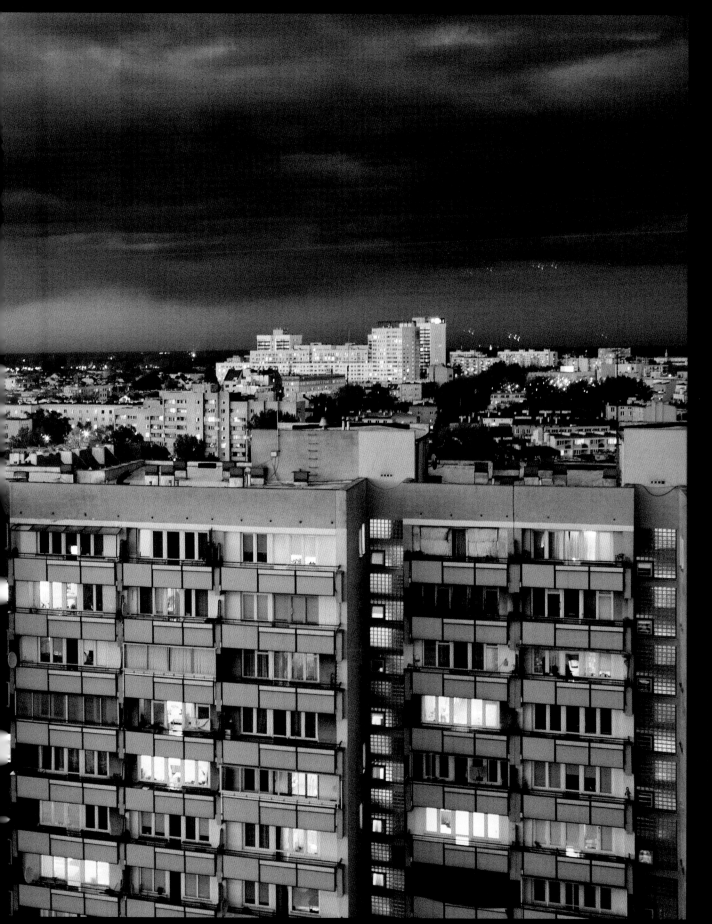

Acknowledgments

The photographs presented in this book were made possible by
Jon Stryker: philanthropist, architect, and photography devotee.

This book was made possible in part by a grant from the arcus FOUNDATION*

The book would not have been possible without my subjects, who shared
very intimate stories of their lives, experiences, and reflections with me.

Thank you E, J, J, Stanisław, Maks, Jarek, Błażej, Joanna, Krzysztof, Anna,
Natalia, Tomek, Patryk, Julia, Ania, Magda, Adam, Dawid, Beata, Artur,
Miko, Monika, Agnieszka, Artur Barbara, Roma, Christopher, Przemek,
Robert, Bartosz, Edward, Edyta, Yga, Anna G., and Robert.

I was fortunate to meet people who believe this subject is extremely
important and worth support. Thank you Jurek, Lisa, Emma, Manny,
Yoko, and everybody at EWS Studios and Arcus Foundation for including
me in the still-growing series. Thank you so much for your patience,
flexibility, commitment, and skills.

Special thanks to Robert for the meaningful words and also Ania and
Agnieszka for the hard work.

Thank you all!

*The Arcus Foundation is a global foundation dedicated to the idea that people can live in
harmony with one another and the natural world. The Foundation works to advance respect
for diversity among peoples and in nature (www.ArcusFoundation.org).